# STAFFORD
## From Old Photographs

# STAFFORD
## From Old Photographs

### JOAN ANSLOW & THEA RANDALL

AMBERLEY

First published by Alan Sutton Publishing Limited, 1994
This edition published 2009

Copyright © Joan Anslow & Thea Randall, 2009

Amberley Publishing
Cirencester Road, Chalford,
Stroud, Gloucestershire, GL6 8PE

www.amberleybooks.com

British Library Cataloguing in Publication Data.
A catalogue record for this book is available from the British Library.

ISBN 978-1-84868-499-7

Typesetting and origination by Amberley Publishing
Printed in Great Britain

# Contents

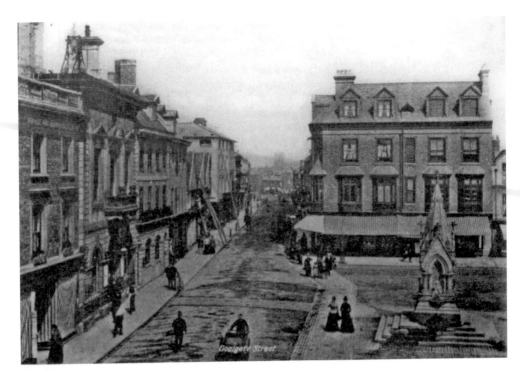

Looking down Gaolgate Street from Market Square, *c.* 1905. Most of the buildings on the left, including the police station with the bell on the roof, have now been replaced. The Jubilee Fountain in the right foreground has also disappeared.

# Introduction

After the considerable local interest generated by *Around Stafford in Old Photographs*, the many requests to produce another book, based on the county town itself, were impossible to resist. Another such venture also offered us the opportunity to use a number of interesting photographs, which it had not been possible to include in the previous book because of the lack of space, and to emphasize further particular aspects of the town's history and heritage.

Stafford has few claims to real fame. It was the birthplace of Izaak Walton, the author of *The Compleat Angler*, and R.B. Sheridan, the playwright, was its MP from 1780 to 1807. In its main street can be found the tallest half-timbered house in the country, an architectural gem. Despite this and some other fine buildings, including a Georgian Shire Hall, two medieval parish churches and what was once a plethora of half-timbered houses, it earned the ignominious and bad-tempered description from Charles Dickens of being 'as dull and dead a town as anyone could wish to see'. We hope that the following selection of photographs will show that Stafford was neither dull nor dead.

Originally a walled town, Stafford was geographically confined by the River Sow and by an extensive tract of marshland. Of its medieval walls and gates barely a trace remains, but the layout is still reflected in its street names – North and South Walls, Greengate, Eastgate, Foregate and Gaolgate Streets. The extent of the walled town was relatively small, more or less conterminous with today's shopping area and the administrative centre of the county and borough. Although substantial changes have occurred 'within the walls', in terms of new shops and office buildings, it is 'outside the walls' that the major developments of the nineteenth and twentieth centuries have taken place. Ring roads now cut across what were once the Kings Pools and the protective marshland. Housing and industrial developments have ensured that the once confined town is now linked to the old settlements of Tillington, Kingston, Rickerscote, Baswich, Castlechurch and Doxey. The photographs here not only emphasize these changes but also give an impression of Stafford as it was before the inexorable advances of the second half of this century.

Old photographs always evoke interest in how the town looked in the past and a nostalgia for the buildings which have gone forever. A town is nothing however without its people and the economic and social life which sustains it. Among the photographs chosen here there are some which illustrate the economic base on which Stafford made its name in the nineteenth and early twentieth centuries, the boot and shoe and engineering industries. The more traditional working activities of the town, retail trades and services, are also reflected.

Leisure time was precious when the working week was longer than it is today. Sporting activities especially played an important part in daily life. It is easy in these times to forget the degree to which local industries could dominate a town's social as well as its economic life, providing sports teams and other social activities for their employees. The popularity of the cinema as a twentieth-century pastime is also reflected

here by some examples from an extraordinary collection of photographs of the inventive promotional activities of a former manager of Stafford's Odeon Cinema during the 1950s and 1960s.

The following pages also show something of how Staffordians celebrated national and local events, with less sophistication than today but probably with a great deal more genuine enjoyment. The pains and pleasures of childhood are also touched upon as are the reactions of the townspeople to two world wars.

Our choice of photographs does not claim to be fully comprehensive but, through the frozen moments of photography, we can catch a glimpse of Stafford as it was and as it will never be again. We hope that this book will give old Staffordians some nostalgic pleasure while providing newer Staffordians with some insight into the history and heritage of their adopted town.

Joan Anslow
Thea Randall

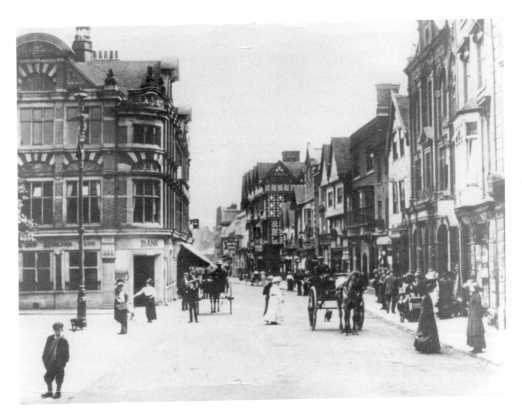

Looking down Greengate Street from Market Square, *c.* 1910.

# SECTION ONE

# Within the Walls

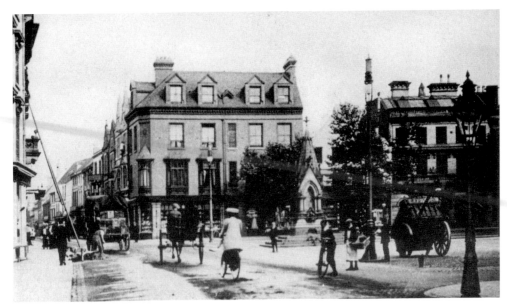

Market Square, *c.* 1910. Facing the camera is Mummery's jeweller's shop, with the Jubilee Fountain to the right. The gas street lamp in the foreground is augmented by a new electric lamp.

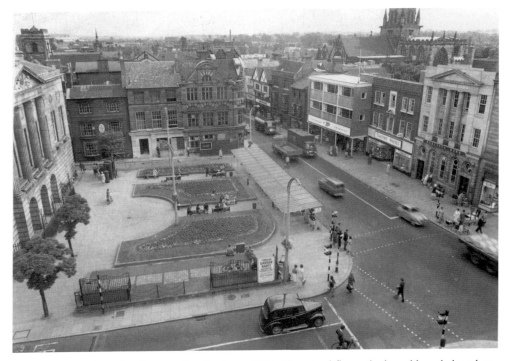

An aerial view of Market Square taken in about 1960. The raised flower beds and bus shelters have recently been removed and this area is now pedestrianized.

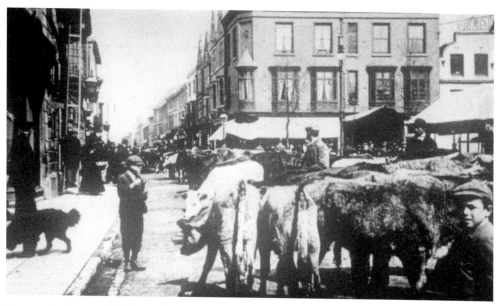

Livestock sales were held several times a year in Stafford. Cows were bought and sold in Gaolgate Street and in the Market Square. Complaints about the inconvenience and mess finally forced the sales to be moved to the Smithfield.

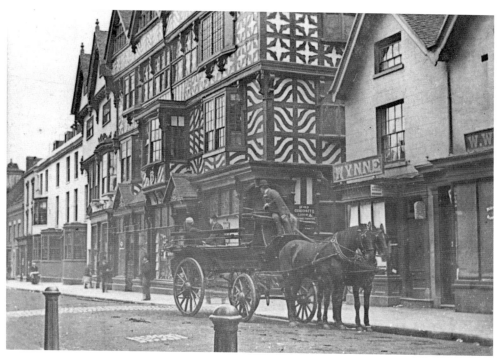

Greengate Street, showing the Ancient High House, *c.* 1900. The brake looks as though it is waiting for passengers.

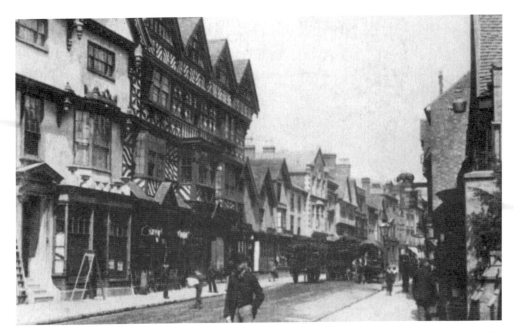

Looking north up Greengate Street, *c.* 1880. The house to the left of the High House with the elaborate doorway was called Shaw's House, named after a shoemaker who lived there in the early nineteenth century.

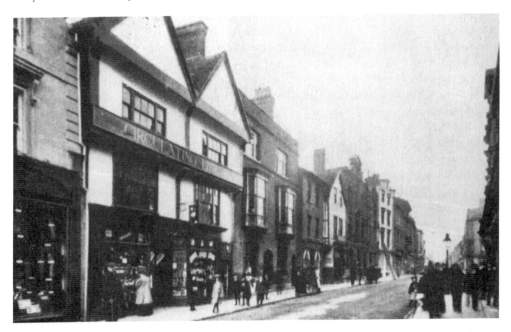

Greengate Street as it opens into Market Square. The shop on the left advertises its circulating library. The shop fronts have changed but the upper storeys still look very much as they did here in 1912.

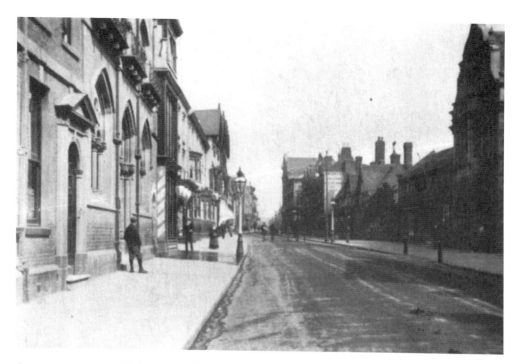

Greengate Street, *c.* 1900, showing the elaborate Gothic frontage of the District Bank on the left.

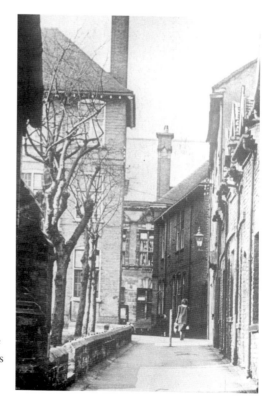

St Chad's Passage runs at the back of St Chad's church. The cottages on the right housed outworkers in the shoe industry in the nineteenth century. The County Social Services offices now stand on the site of the cottages.

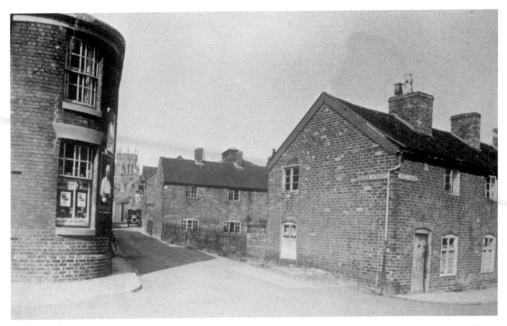

Water Street in about 1920, with the tower of St Mary's church on the skyline. This area has been completely redeveloped and a new doctors' surgery stands on the site of these cottages.

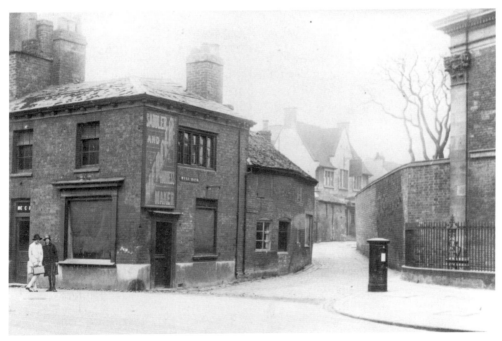

Mill Bank, 1926. This street followed the line of the town walls. The junction with Greengate Street, seen here, was the site of the Green Gate, the main medieval entrance to the town.

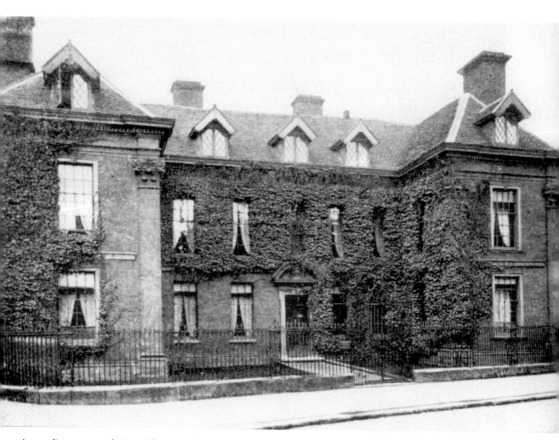

According to tradition Chetwynd House was built in 1746 by William Chetwynd. Richard Brinsley Sheridan, the playwright and Stafford's Member of Parliament from 1780 to 1807, often stayed here with his friend, William Horton. Seen here in about 1900 as a town house, it has been Stafford's General Post Office since 1914.

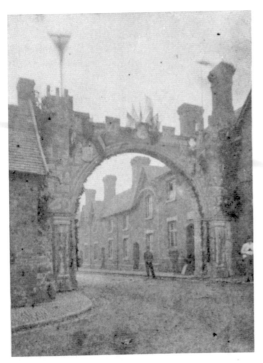

In April 1873, Prince and Princess Christian, the son-in-law and daughter of Queen Victoria, visited Ingestre Hall. This replica of Stafford's East Gate was erected on the site of the original gate for them to pass through.

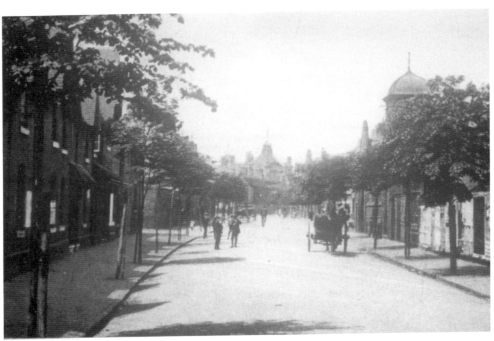

Eastgate Street in 1900. This was a charming, tree-lined thoroughfare, with a mixture of timbered houses, eighteenth-century town houses, nineteenth-century cottages and a few shops.

Pitcher Bank in the 1960s. This was the site of the old crockery market. It forms a junction between Eastgate Street and Tipping Street. Tipping Street was also known as The Diglake, Chipping Street and Dog Lane. Most of the property seen here has now been demolished.

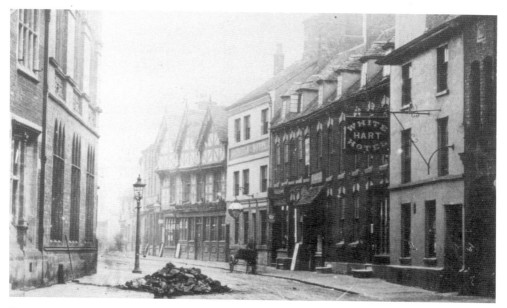

Eastgate Street, *c*. 1900. The Borough Hall is on the left, while on the right are three public houses, the Fox and George, the Sheridan and the White Hart. In the middle of the street a heap of coal can be seen, probably for the use of the boilers at the Borough Hall.

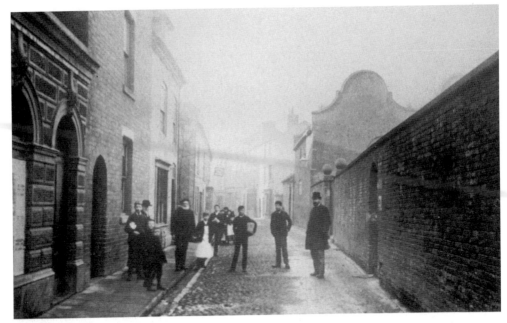

Martin Street. This photograph must have been taken before 1895, when County Buildings were built to replace the houses on the right. On the left of the street, in the immediate foreground, is the Lyceum Theatre, replaced by more County Council offices during the 1920s.

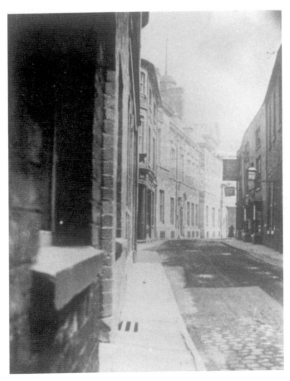

Martin Street, c. 1905. The new County Buildings can be seen on the left while opposite on the right are the Old Blue Posts and The Fountain public houses. The County Planning Offices are built on this site.

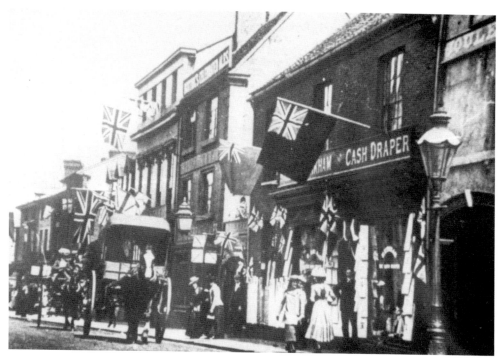

Gaolgate Street from the north. The flags could be in celebration of George V's coronation.

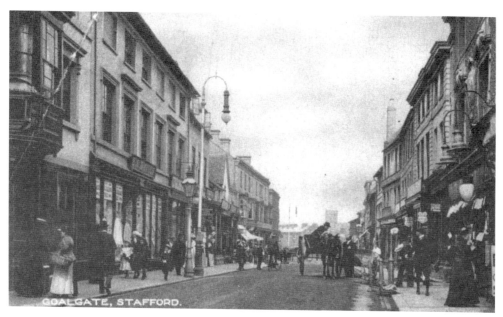

Looking north up Gaolgate Street, *c.* 1905. Note the misspelt postcard caption. There is a new electric street light next to the gas lamp – nothing like being doubly sure! In the distance the silhouette of Christchurch can be seen.

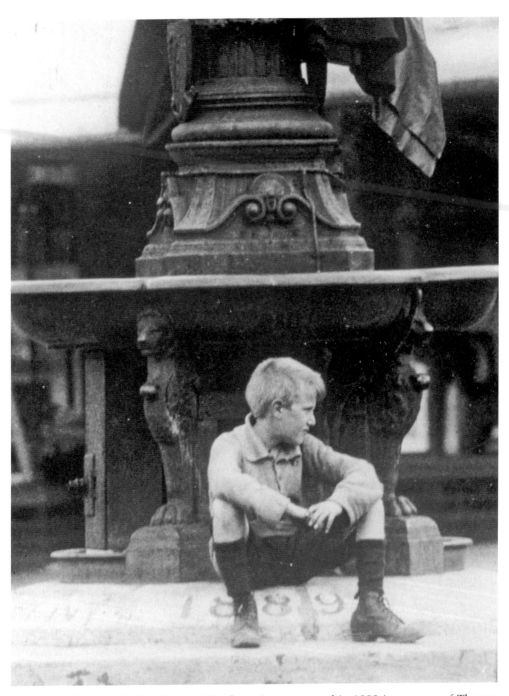

The Sidney Fountain in Gaol Square. The fountain was erected in 1889 in memory of Thomas Sidney (1805-89), a Stafford man who was Lord Mayor of London in 1853/4. The fountain was destroyed in 1928 when a van backed into it and this photograph was taken probably not long before that event.

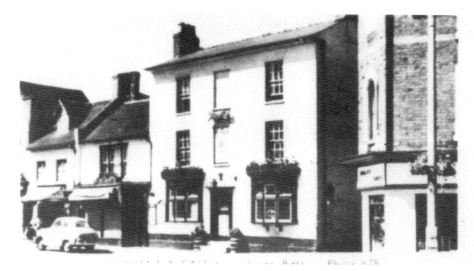

The Elephant and Castle in Gaol Square was demolished when the area was redeveloped in the 1970s to make way for a ring road.

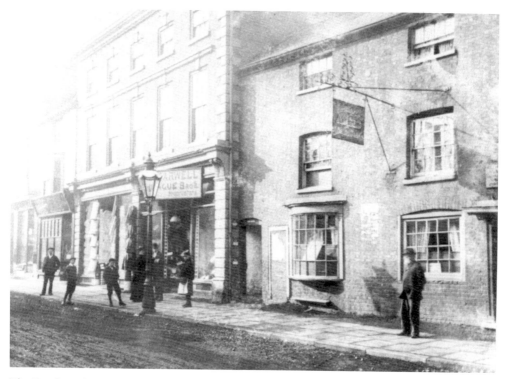

The Butchers Arms in Gaolgate Street roughly opposite the present site of Marks and Spencer. Stafford's public houses were so numerous that a 'drinks map' was drawn in 1883 showing where they all were.

Cherry Street, *c.* 1890. This street of tiny cottages disappeared to make way for Stafford College. In Victorian times a dairy in Cherry Street kept cows on the premises and the milk was carried round to the customers on a yoke.

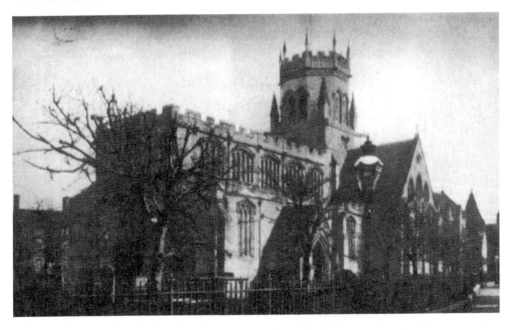

The Collegiate Church of St Mary, the parish church of Stafford, dominates the town. It was built to the east of the original Saxon chapel of St Bertelin. The iron railings seen here around the churchyard were removed during the war as part of the drive for scrap metal.

A charming corner of old Stafford, now unrecognizable. 'Averill's Entry', as it was known, is still there today and leads from St Mary's Grove into Greengate Street. Originally it came out by Averill's old shop, a fifteenth-century half-timbered house demolished in the 1960s. The timbered building on the left of the photograph was an old Dame school.

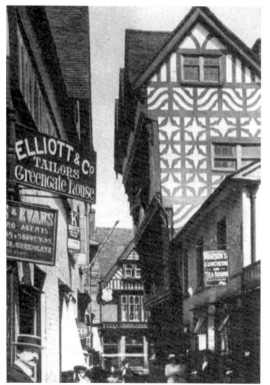

St Mary's Passage, leading from St Mary's churchyard into Greengate Street. The Ancient High House can be seen clearly on the right. The Bear Inn, originally the White Bear Inn, still stands opposite, but the timbered shops on the left sadly have gone.

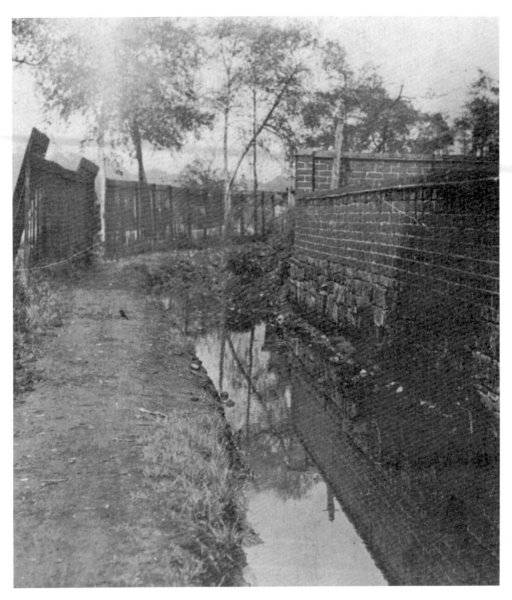

A remnant of the old town wall which still stood in the 1920s. The Thieves' Ditch ran behind it, a convenient dump for the town's rubbish over the centuries.

# SECTION TWO

# Are You Being Served?

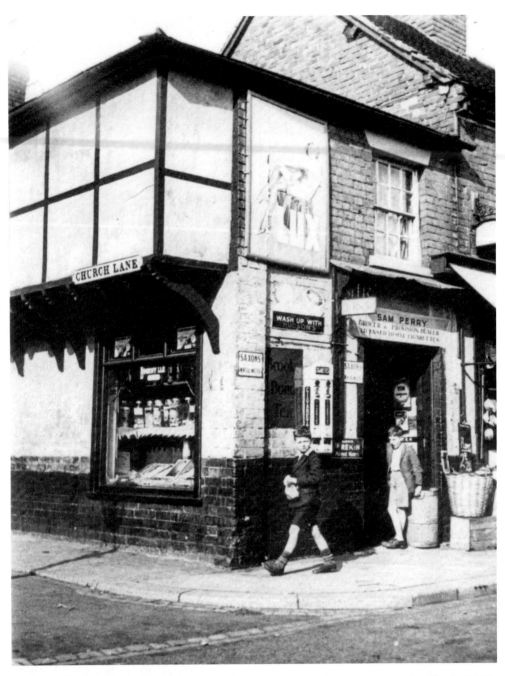

Perry's, on the corner of Mill Street and Church Lane, was a thriving grocer's shop in the 1930s when this photograph was taken.

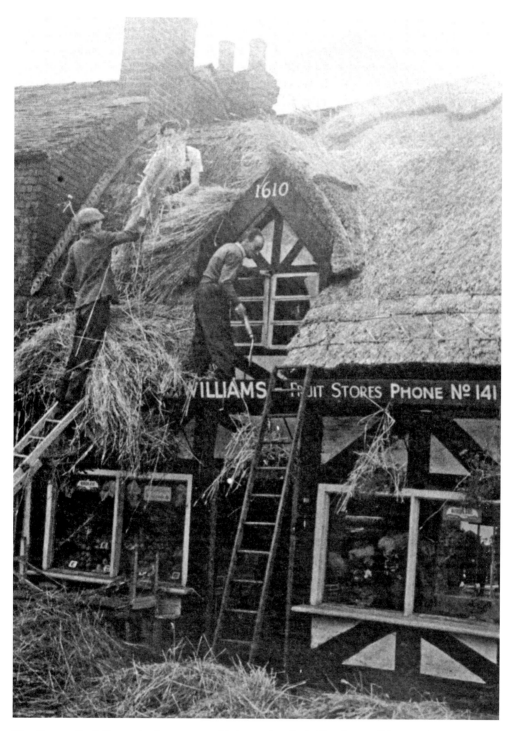

The County Fruit Stores in the process of being rethatched. The shop still has its thatched roof.

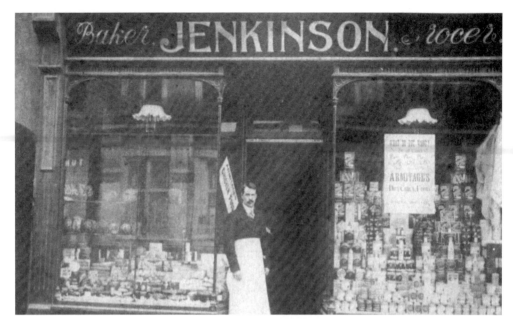

Jenkinson's grocer's shop in Greengate Street, next to Averill's Entry. The window display shows an interesting variety of goods.

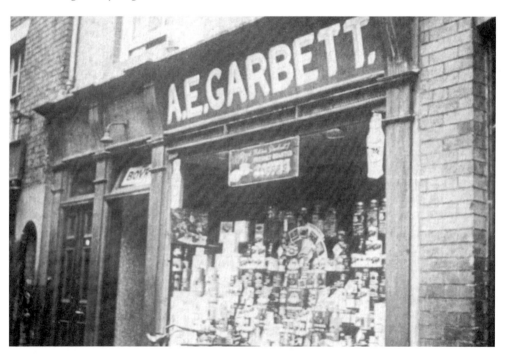

Garbett's was in 'Smoaky Lane', the pedestrianized part of Martin Street, leading to Greengate Street. The delivery bike is waiting to be piled high with orders to be taken round the town. Garbett's survived until the 1960s.

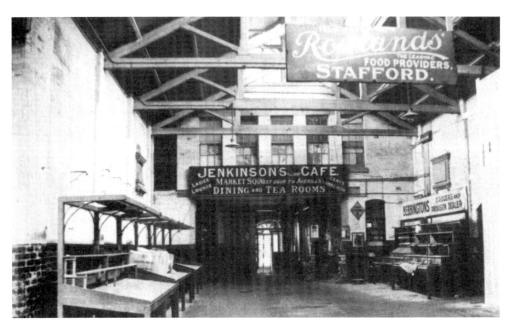

The interior of the old market hall in the 1920s. This area has now been redeveloped as a shopping mall and new market.

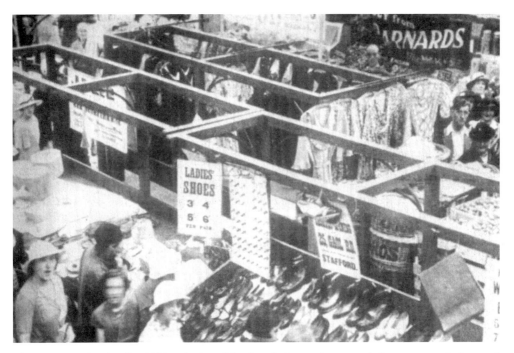

The main market in the 1930s. A cheerful mix of cheese, boots and shoes, eggs, clothes and sweets, there was no nonsense about segregation here. A good pair of ladies' shoes cost between 3s and 6s, a hundredth of the average price today, sixty years later.

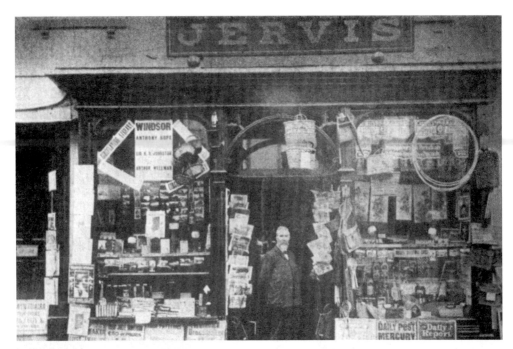

Jervis' Stationers and Fancy Goods shop, originally in Gaolgate Street, ran a circulating library in 1912. This well-known business had been in Stafford for over 100 years when it closed finally in 1993.

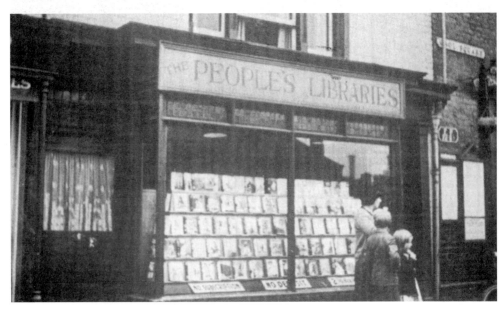

The People's Libraries was in Gaol Square, next to the Elephant and Castle. The shop previously belonged to Mr Richardson, a brushmaker, known locally as 'Brushy' Richardson. In 1906 Lloyd George gave an election speech to a crowd of supporters from the upper window seen here.

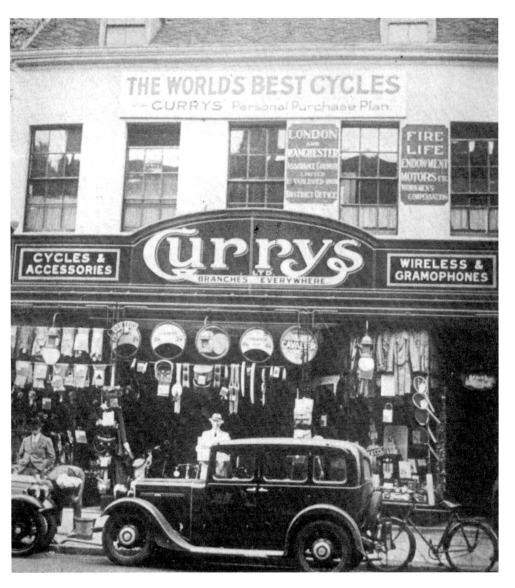

Currys shop was in Greengate Street, opposite the old District Bank. In 1930 it sold bicycles, sports equipment and wirelesses.

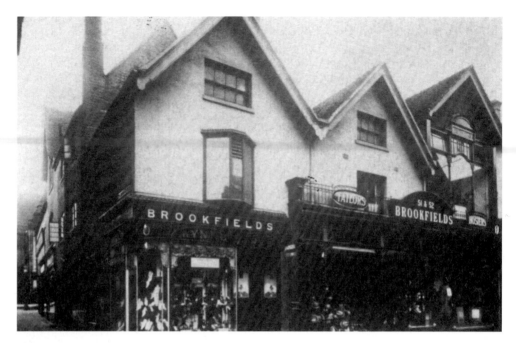

Brookfields, on the corner of Greengate Street and St Mary's Passage, sold top quality shoes and clothes and were also bespoke tailors. The shoe shop had previously been Wynnes and this name can still be seen on the shop front.

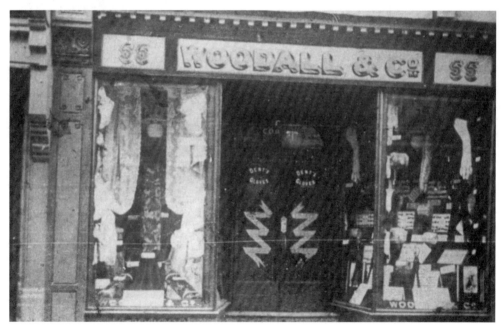

Woodall's drapery shop was a little further up the street from Brookfields. The shop sold high quality dress and curtain materials and sewing accessories and only closed finally in the late 1970s.

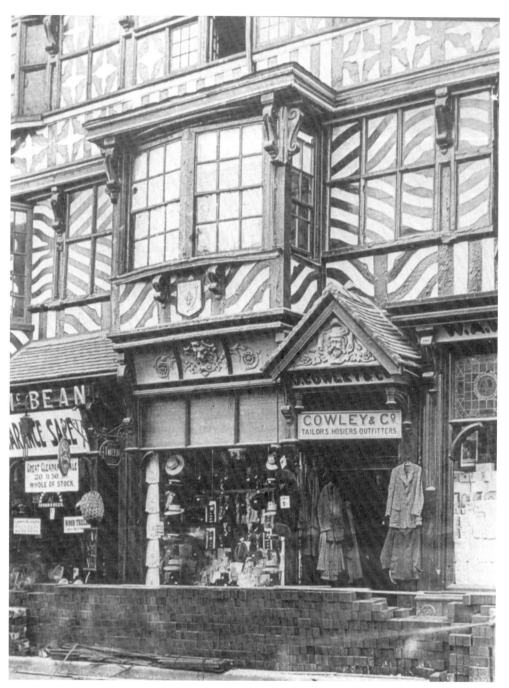

Greengate Street was being resurfaced when this photograph was taken in about 1910. Cowley's tailor's shop in the bottom of the High House had a great rival on the opposite side of the street. Neither shop would close until the other one did, which meant sometimes staying open until 10.00 p.m. on a Saturday night.

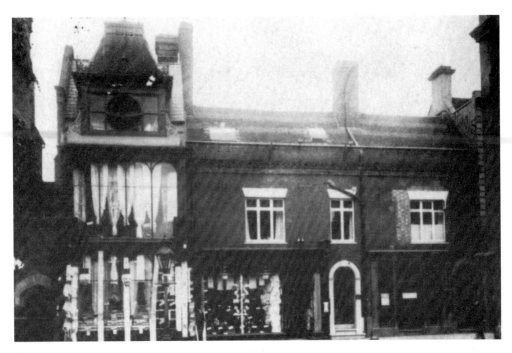

The Manchester and Bradford Warehouse, a draper and haberdasher, was in Greengate Street opposite the end of Tipping Street.

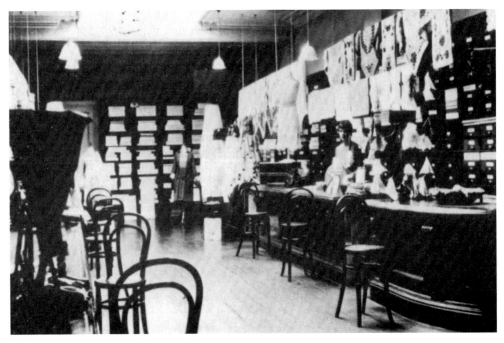

The interior of the Manchester and Bradford Warehouse, which was fitted out with heavy polished counters and drawers.

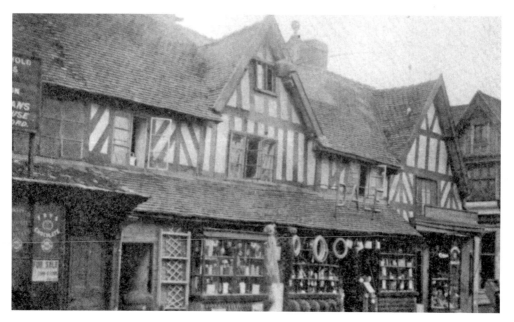

Dale's Old Shop was a Tudor building opposite the Ancient High House. Its use as an ironmonger's dates back to 1811. The Dale family ran it from 1826 until its demolition during the 1960s, when it was replaced with modern shops. Remembered with great affection by old Staffordians, it had a large copper kettle hung from its central gable and, in the fishing season, a rod and line, complete with fish.

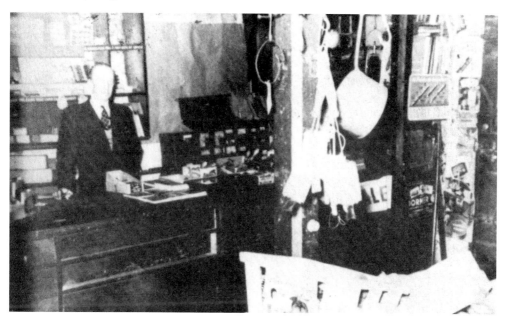

This photograph of the interior was taken shortly before it closed and gives some idea of the varied stock which it carried.

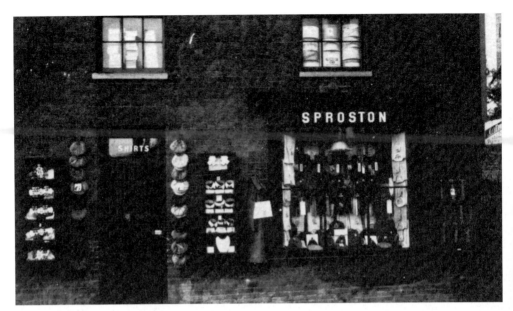

Sproston's menswear shop stood on the site of the Oddfellows' Hall at the corner of Tipping Street. Stiff collars, tweed caps, shirts, ties and braces are all crammed into the window.

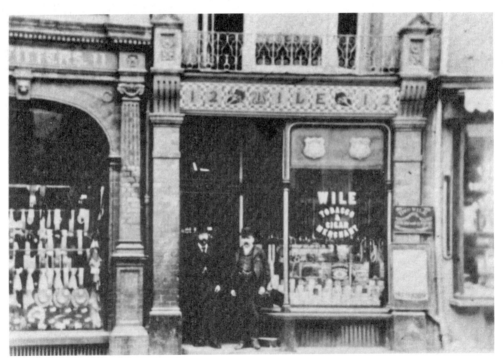

Wile's, Tobacco and Cigar Merchants, was in the Market Square. A gas jet was permanently lit in the shop for gentlemen to light their cigars.

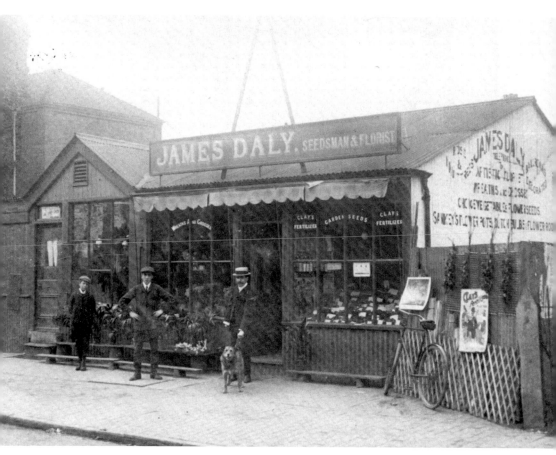

James Daly, seedsman and florist, kept his shop in Newport Road for over sixty years until 1965. The dog seen in the photograph was called Yippee and was very good at regularly upsetting pub spittoons!

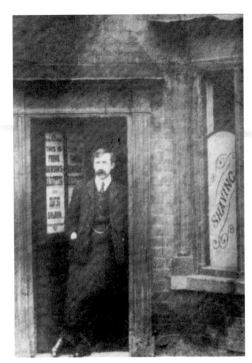

Frank Dawson's Hairdressing Salon,
4 Bridge Street, *c.* 1904.

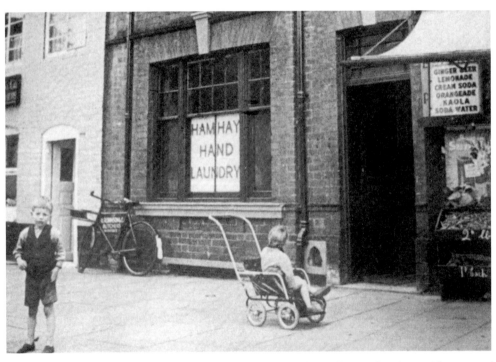

Ham Hay's Chinese Laundry in Eastgate Street, opposite the William Salt Library. This row of shops and cottages has now been replaced by the new police station.

# SECTION THREE
# Gone Forever

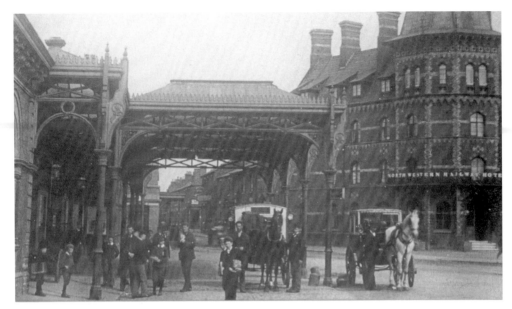

The third Stafford railway station, built in 1862. This fine Victorian station replaced a smaller one built during the 1840s, which had in turn replaced a makeshift station of 1837, provided when the railway first came to Stafford. The splendid canopy was made of cast iron.

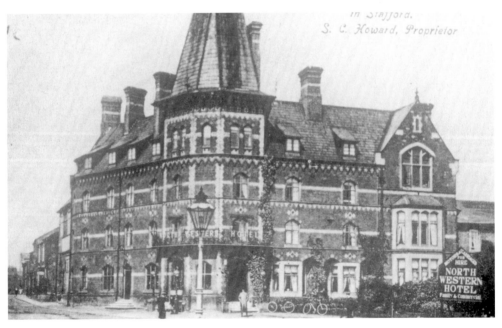

Opposite the station stood the Italianate-style North Western, later the Station, Hotel, which opened in 1866. When the hotel was demolished in 1972, so was the row of houses next to it on Victoria Road.

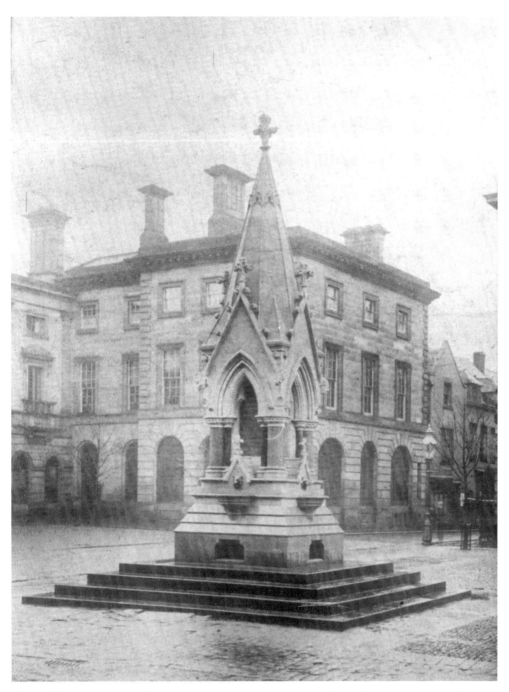

The Jubilee Fountain in Market Square was erected to celebrate Queen Victoria's Diamond Jubilee in 1897. It provided welcome if unhygienic refreshment for passers-by until 1934 when it was smashed up and removed. Behind the fountain, Stafford Old Bank, now Lloyds, remains almost unaltered on the outside today.

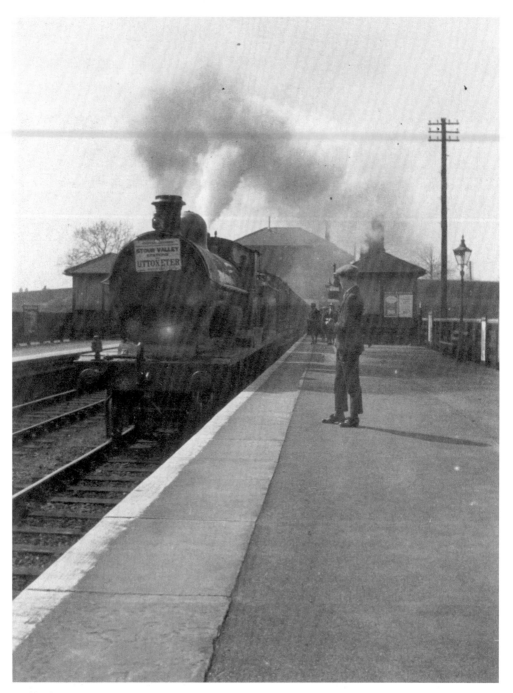

Stafford Common station, Marston Road, in the spring of 1921. The photograph shows a London and North Western Railway excursion train to Uttoxeter, travelling over Great Northern Railway tracks. The locomotive is a LNWR 'Precursor' class. The station was closed in 1968, because of the closure of the nearby saltworks, and the buildings were demolished in 1973.

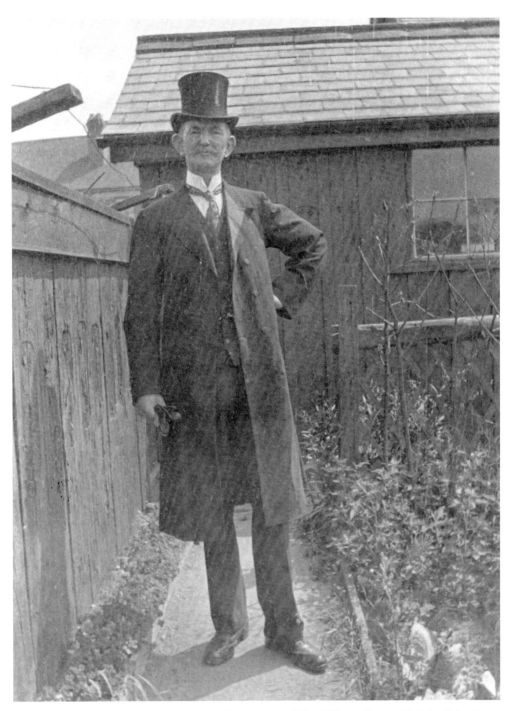

The stationmaster at Common station at that time was John Milburn Foster. He joined the Great Northern Railway at Lincoln in 1887. He came to Common station as stationmaster in 1909 and retired from there in March 1933. This photograph was taken at 11 Common Road.

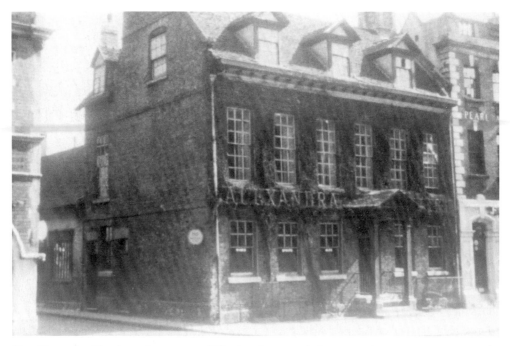

The Alexandra Hotel on the corner of Tipping Street and Greengate Street was a seventeenth-century town house. It is chiefly remembered for the beauty of the Virginia creeper which covered the frontage but which was a source of aggravation for the licensee, who had to prevent it from taking over the windows as well.

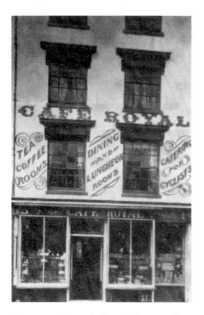

The exterior of the Café Royal in Market Square in about 1910.

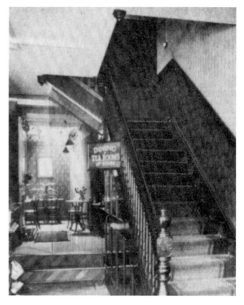

The Café Royal's interior, also photographed in about 1910.

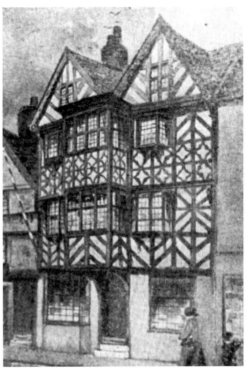

Elizabethan House, situated in Gaolgate Street opposite the end of Craberry Street, was destroyed by fire in 1887. The alarm was raised by a shoemaker, who was said to suffer from 'Cobbler's Monday'. Unfortunately his story was not taken seriously by the police until it was too late and Elizabethan House was razed to the ground. The shoemaker still received a reward of 5s, however, for raising the alarm.

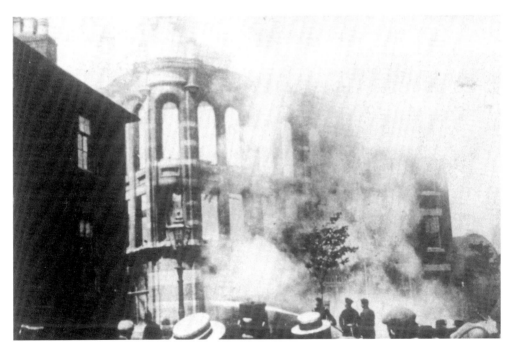

In 1901 Bostock's Shoe Factory in Foregate Street was destroyed by fire. This photograph shows the factory offices in flames. A new factory was opened in 1903 in Sandon Road.

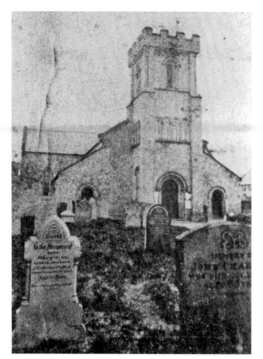

Christchurch was situated immediately outside the site of the North or Gaol Gate of the town. Built in 1839, the building became redundant and was demolished in 1983 to make way for a complex of retired people's flats, while Christchurch's congregation moved to share Rowley Street Methodist church. This early photograph was taken in about 1870.

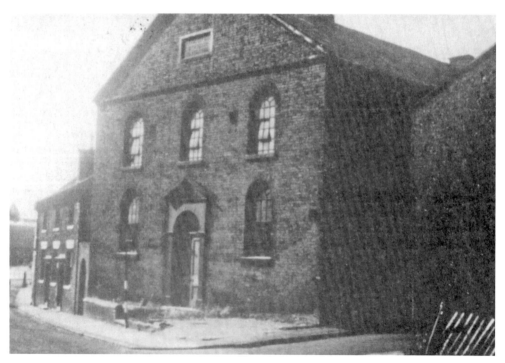

Snow Hill Primitive Methodist chapel, built in 1849, was situated behind Christchurch. Gaol Square can be seen in the distance in this photograph of 1949.

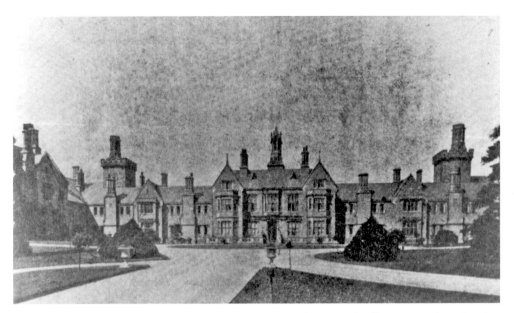

Coton Hill private asylum was opened in 1854 to cater for mentally ill patients whose families could afford to pay for comfortable surroundings and some luxury. The hospital was well equipped and also had its own kitchen garden and orchards to supply fresh food.

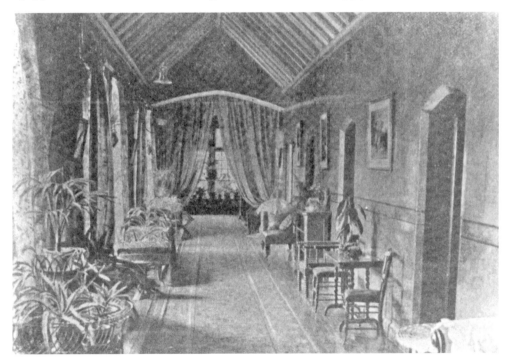

One of the corridors inside Coton Hill, which at first glance could well be mistaken for a corridor in a large private house.

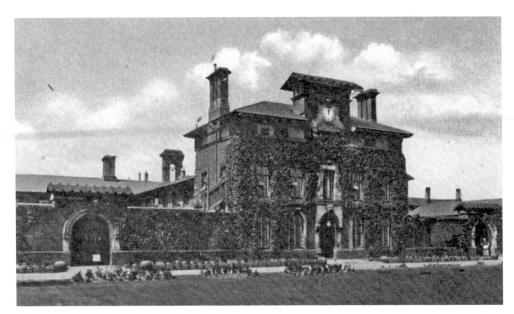

Stafford Union Workhouse, Marston Road, built in 1837-8, seen here about 1905. From 1948 to 1971 the workhouse buildings were used as an old people's home and a hospital called Fernleigh, but were finally demolished after 1971.

Palmer's Almshouses in Broad Street, which were demolished in 1962. The almshouses were endowed originally by Revd John Palmer, rector of St Mary's, in 1639.

# SECTION FOUR
# Outside the Walls

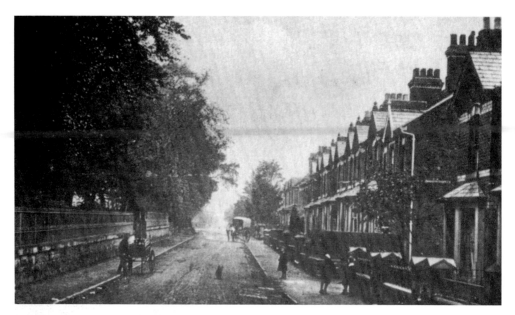

Tillington on the road to Eccleshall, *c.* 1905. The long wall and railings on the left adjoin the town cemetery. The houses on the right would have been relatively new at this date.

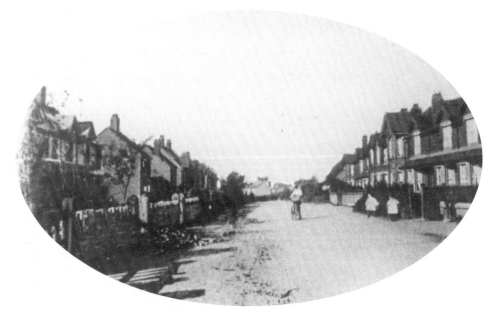

Doxey, *c.* 1908. The road looks very similar today. The houses were large and well built and most have very long gardens. A Stafford doctor wanted to build a convalescent home in Doxey about this time because it was the healthiest place in the area. This was possibly because it is on higher ground than the rest of the town, which is notorious for being damp.

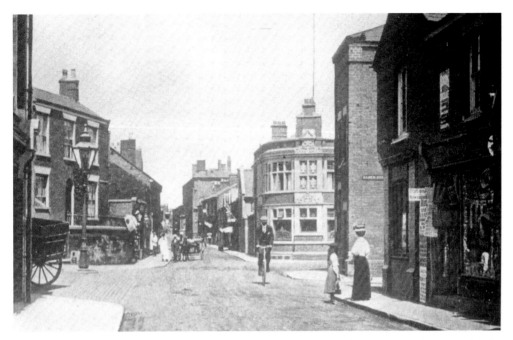

The crossroads at Marston Road, Gaol Road, Rowley Street and Sandon Road, *c.* 1910. The north of Stafford was developed to provide accommodation for workers in the shoe factories, most of which were situated in this area.

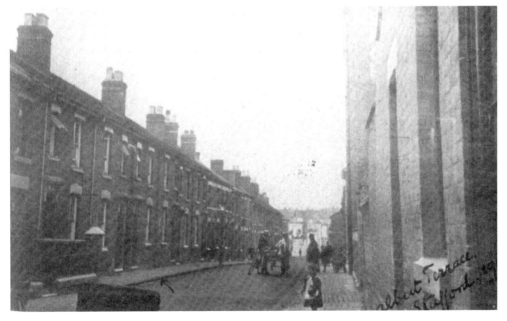

Albert Terrace in 1915. A typical street of artisan housing, this neat and narrow street is often congested today with cars, a problem not thought of when the houses were built.

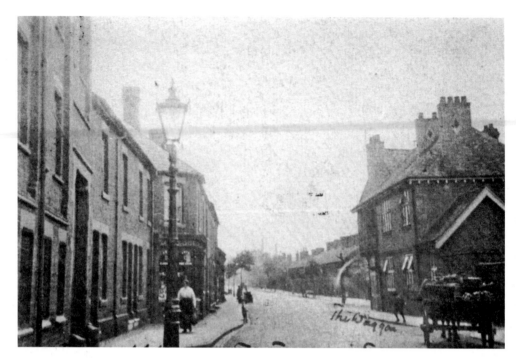

Looking down the Foregate in 1911, a wide and tree-lined road. Deavall and Johnson's shoe factory is on the left and The Waggon and Horses public house is on the right.

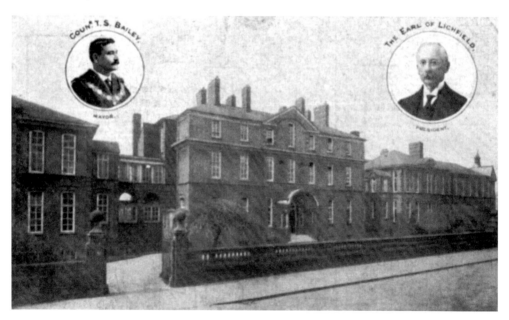

The General Infirmary began its days in 1765 in a rented house in Foregate Street. By 1772 a custom-built hospital had been completed, seen as the central block in this photograph.

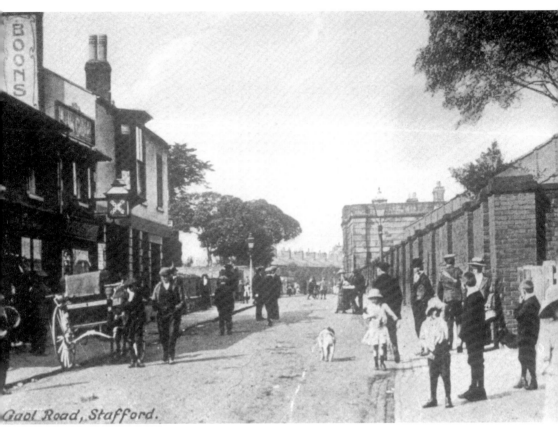

Gaol Road, Stafford.

This photograph of Gaol Road in about 1910 shows a busy bustling area, overshadowed by the walls and gatehouse of the 'new' county gaol, which had been built in the late eighteenth century. Crenellated like a castle, it stretches along the road like a great fortress. Originally public hangings were carried out on the top of the flat gatehouse, creating entertainment for locals and train-loads of sightseers who came to see the execution of notorious criminals, like William Palmer, the Rugeley poisoner.

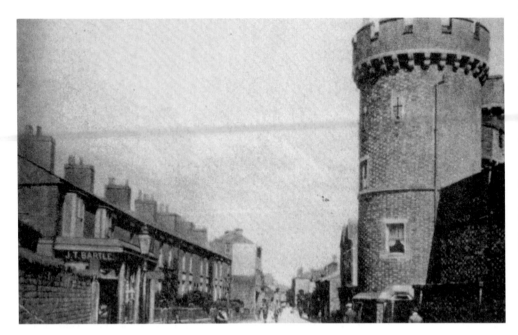

Stafford Gaol's great towers at the corner of Crooked Bridge Road were built as accommodation for the turnkeys and their families. They had to be taken down in the 1960s when they were found to be unstable owing to brine pumping beneath them.

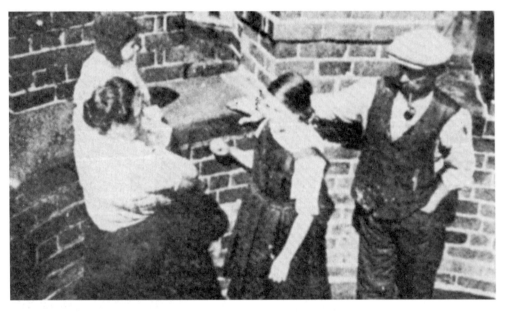

After the First World War there was a shortage of housing in the town. As the Gaol was not in use at the time, one of the towers was let as living accommodation for a weekly rent of *9s 9d*. The rooms were round and the floors were of dusty stone. This photograph was taken on top of the tower in 1926.

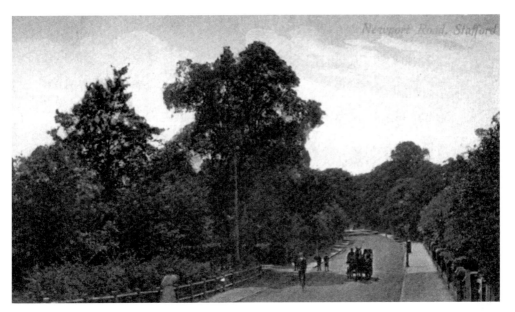

Newport Road, to the west of Stafford, *c.* 1900. At that time this was still a rural road.

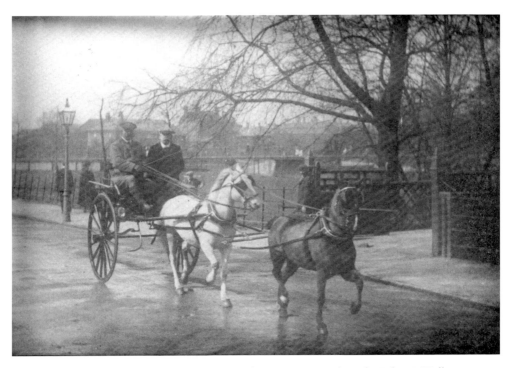

Newport Road, *c.* 1910, showing the weir on the River Sow and Izaak Walton's Walk.

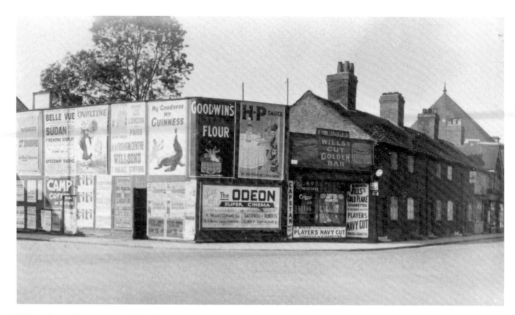

These hoardings were placed at the corner of Newport Road and Bailey Street in the early 1930s. The small black doorway on the left led to a gentlemen's public lavatory which had been removed from Gaol Square to this less public place. The Odeon Cinema was built on this corner and opened in 1936. Shops replaced the cottages to the right.

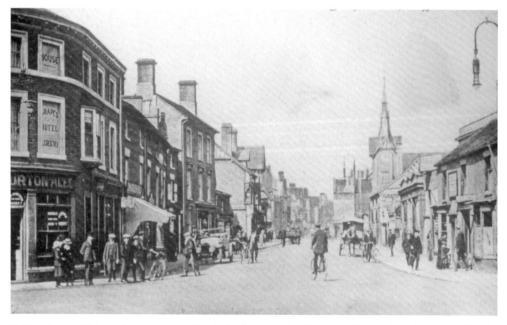

Bridge Street. This is the area immediately in front of the Green Bridge and is the site of the old Green Gate. By 1900 it had become built up with shops. The tower on the right is that of the Royal Brine Baths.

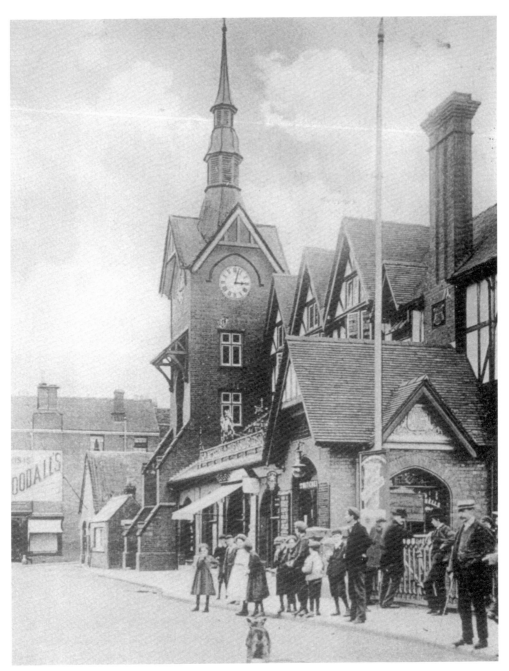

The Royal Brine Baths were built in 1892 after a lake of brine was discovered while drilling for water on Stafford Common. Designed by George Wormald, they included a brine swimming bath and single baths, used for therapeutic treatments. The tall clock tower seen here was used to dry the hoses of the Volunteer Fire Brigade. The baths were demolished in 1977 after the brickwork was found to be unsafe.

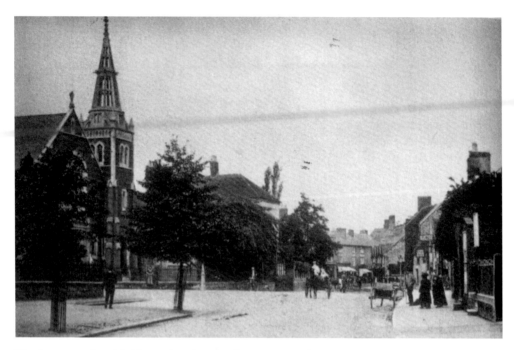

The junction of Lichfield Road and Wolverhampton Road, *c.* 1910, showing the Baptist church on the left.

These large houses stood a little further along Lichfield Road. The house to the right had a garage business built in front of it during the early days of motoring. The garage was Baileys and a garage business remained here until the new ring road was built straight through this site during the 1970s.

These thatched cottages stood on Lichfield Road, opposite Green Hall.

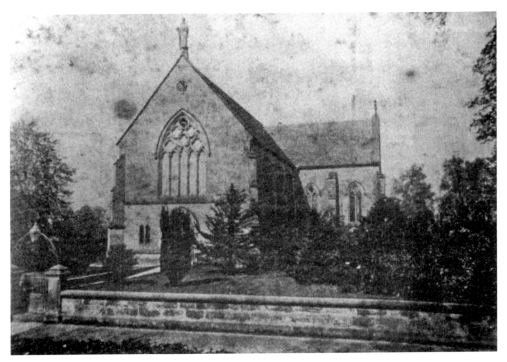

St Paul's church, Forebridge. This early photograph was taken before the tower and spire were added in 1887.

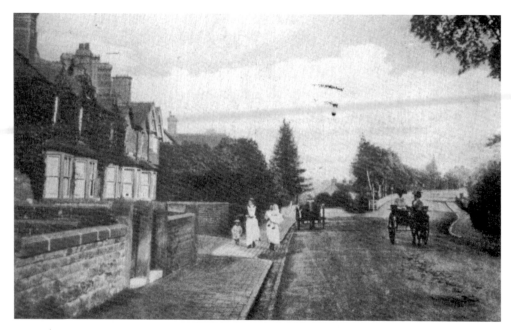

Queensville was developed for housing in the Edwardian era. The area was bisected by the railway line and had a level-crossing by The Crown. When the level-crossing became unsafe, Queensville Bridge was built.

Radford Bank, *c.* 1905.

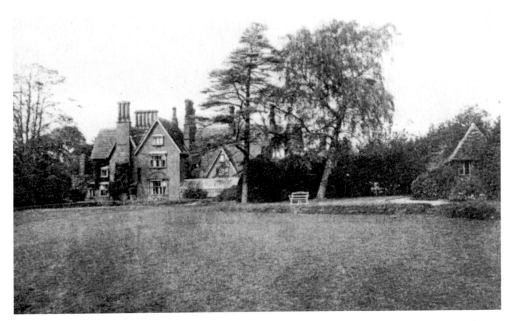

Baswich House, seen here in about 1920. Originally the home of the Salt family, by this date it had become a preparatory school. Now it is the Staffordshire Police Headquarters.

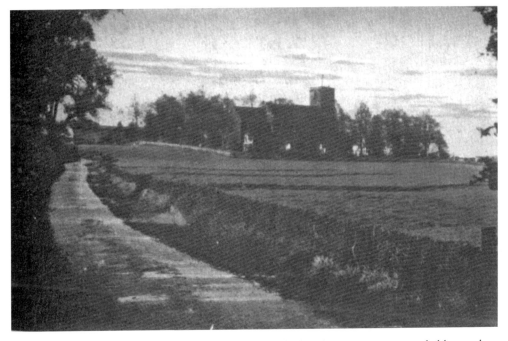

Holy Trinity, Baswich, c. 1905. Formerly a rural parish church, it is now surrounded by modern housing.

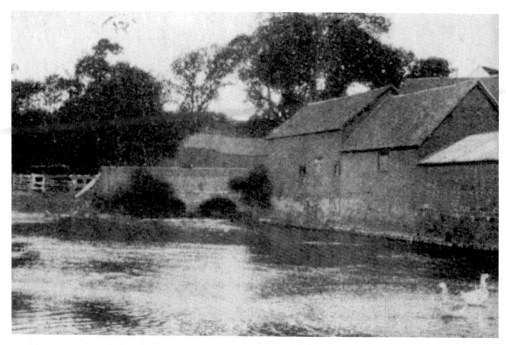

St Thomas' Mill in the early part of the century. Now a farm, it stands on the site of the medieval St Thomas' Priory.

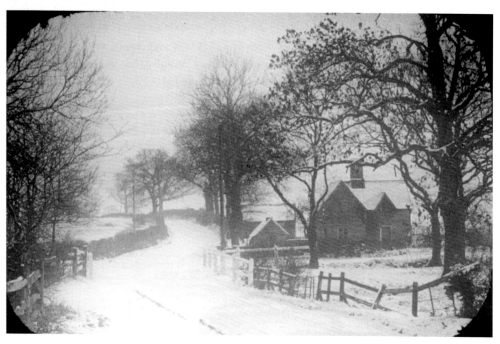

A view of the Tixall Road in the grip of winter.

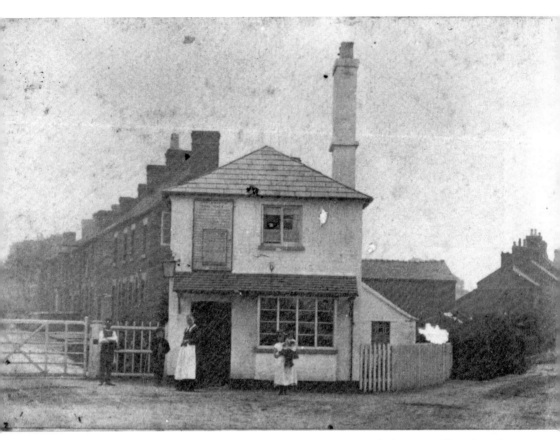

Originally Weston Road and Tixall Road were turnpiked. The tolls which were collected were used for the upkeep of the roads. This photograph shows the toll house at the junction of the two roads. The gates were removed in 1878. A public house, appropriately called The Gate, now stands in place of the toll house.

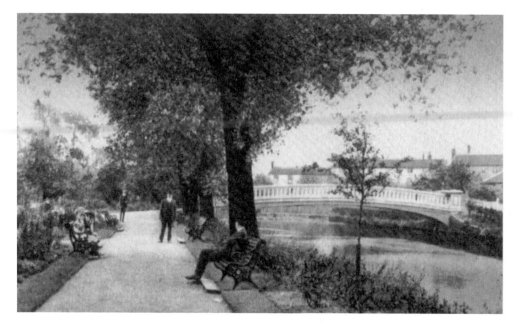

Victoria Park, the idea of an inspired councillor, opened in 1908 and was an immediate success with Staffordians. It was extended in 1910 to include the bowling green, and the Coronation Bridge seen here was built the following year to link the two parts.

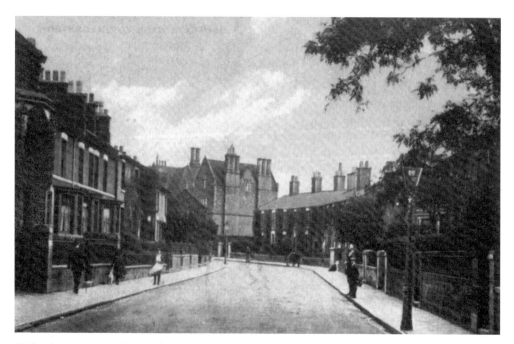

Wolverhampton Road, which was developed for housing as the town prospered in the late nineteenth and early twentieth centuries.

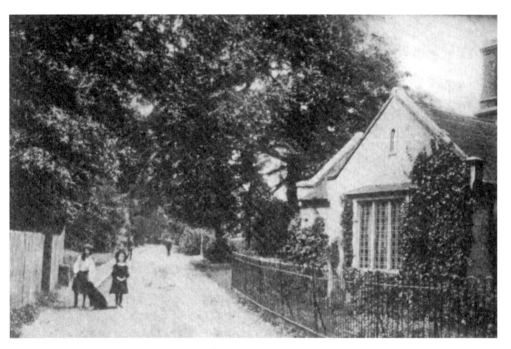

The entrance to Rowley Park. Staffordshire Land Building and Improvement Company Ltd, a short-lived Victorian development company, was formed in 1866 to build superior suburban houses there.

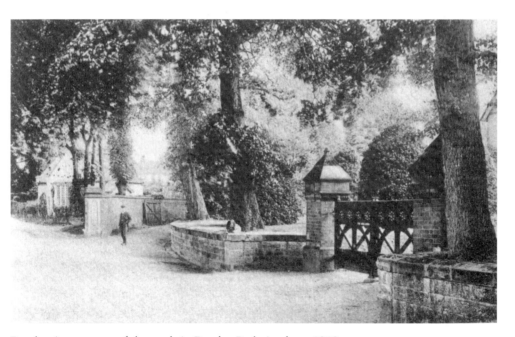

Rowley Avenue, one of the roads in Rowley Park, in about 1910.

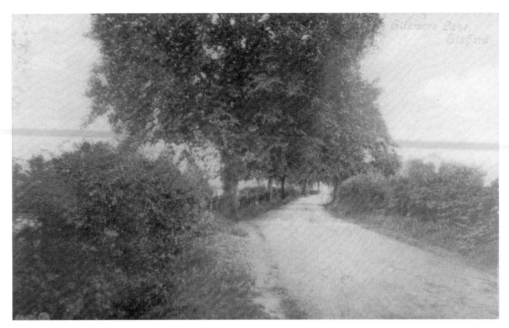

Silkmore Lane early in this century, a far cry from the built-up and busy road of today.

Walton-on-the-Hill in 1900. Still a small rural village when this photograph was taken, it retains its village feel, despite being more closely linked to the town nowadays by housing development.

# SECTION FIVE

# The Younger Generation

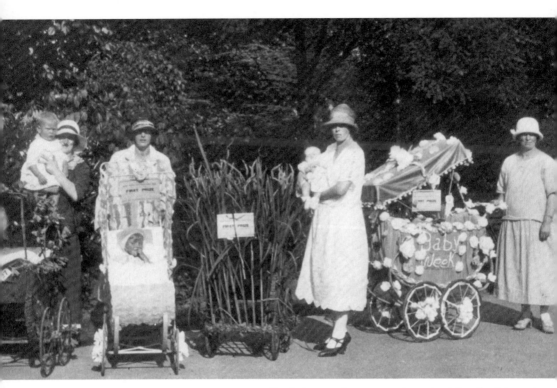

'Baby Day' was an annual event in Stafford during the 1920s. Organized by the Maternity and Child Welfare Committee of Stafford Borough Council, prizes were awarded for the best decorated pram and the bonniest baby. This photograph shows some of the proud prizewinners.

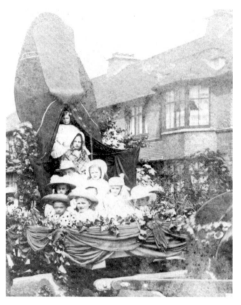

This charming photograph was taken in Wright Street in about 1912. These terraced houses were built for workers in the the shoe factories.

'The Old Woman who lived in a Shoe', a cleverly decorated dray entered in Stafford Pageant in about 1925. The pageant was in held every year to collect funds for Staffordshire General Infirmary.

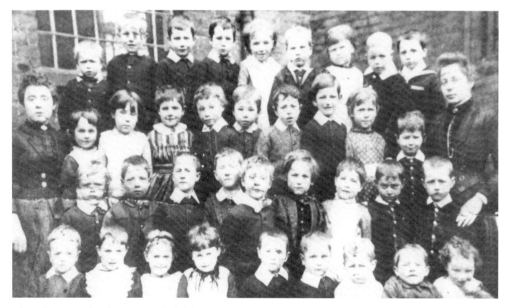

This photograph of a group of children at the British School in Earl Street dates from the 1880s. The parents of these children had to contribute 1½d per week and provide slates and slate pencils for their children.

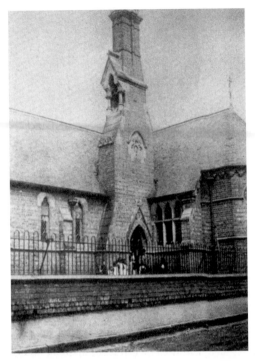

St Mary's School, Littleworth, renamed St John's in 1923. Built in 1885, this building was only recently demolished.

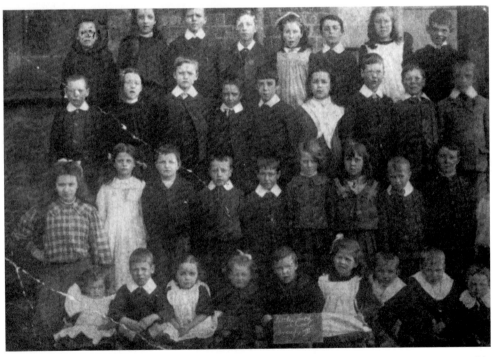

School group at St Mary's, Littleworth, *c.* 1905. Schoolchildren at this time wore dark, serviceable clothes, relieved occasionally by a white pinafore or Eton collar.

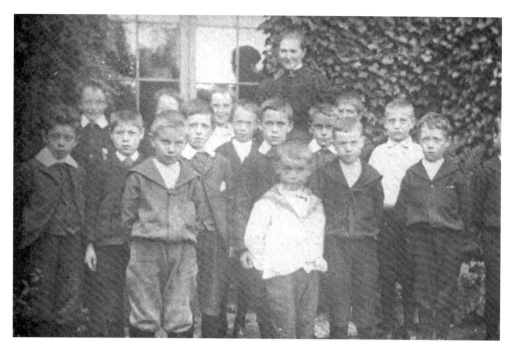

Children at a small private school in Castle Terrace, seen here with their teacher in about 1895.

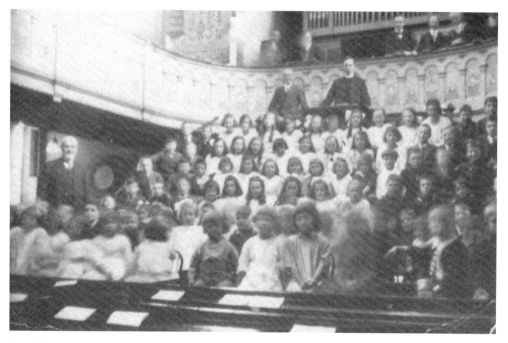

The Wesleyan chapel anniversary, May 1920. The photographer obviously had a problem in keeping the children still.

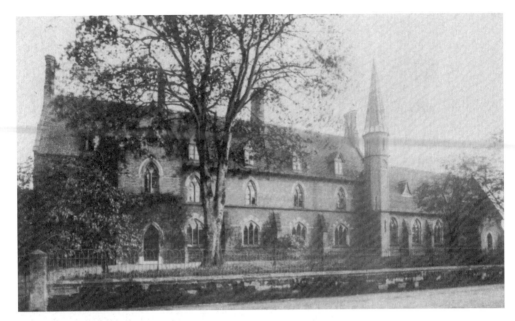

King Edward VI's School in 1900. The school moved to this building in 1862 from premises in Gaol Square. Before 1801 it was housed in the chapel of St Bertelin next to St Mary's church.

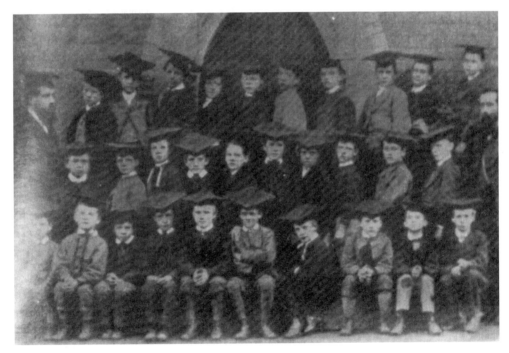

King Edward VI boys, *c.* 1880.

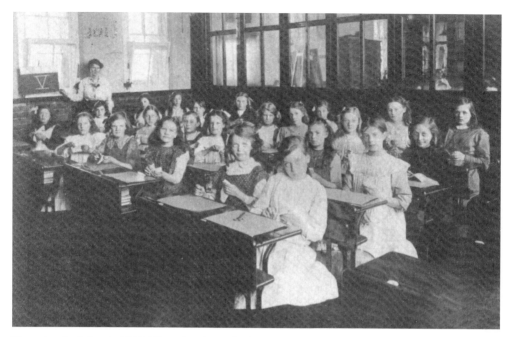

Tenterbanks School, 1912. The school was built in 1910 so this photograph shows a very up-to-date Edwardian classroom. The glass partition could be folded back so that one teacher could teach two classes if necessary.

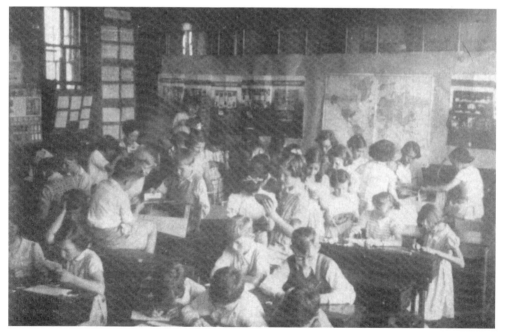

Tenterbanks School, forty years later. The school was demolished in the 1970s to make way for an extension to Stafford College.

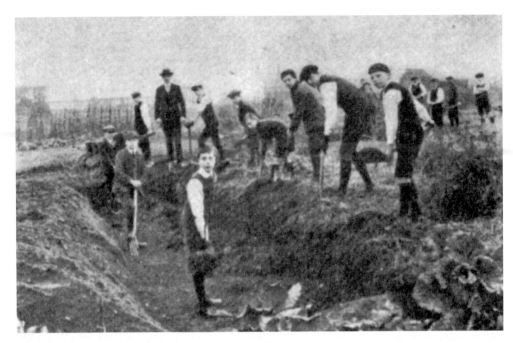

A boys' gardening class at a Stafford school in 1928. Most schools at this time taught boys how to grow food, a useful skill for later life.

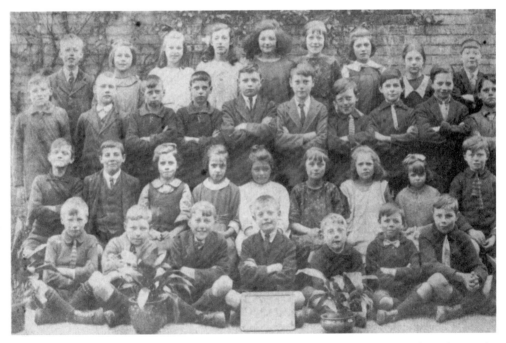

A class photograph at St Paul's Church of England School, Garden Street, taken during the 1920s.

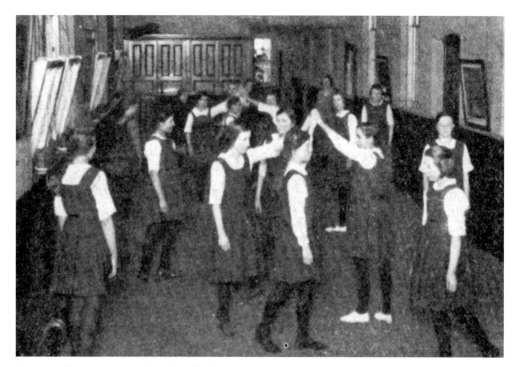

Country dancing at Tenterbanks School, 1928.

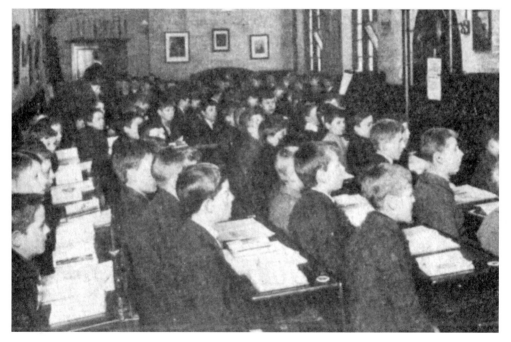

A boys' classroom scene in 1928, possibly St Mary's Church of England School, which was situated next to St Mary's church. The school building is now part of a small shopping complex.

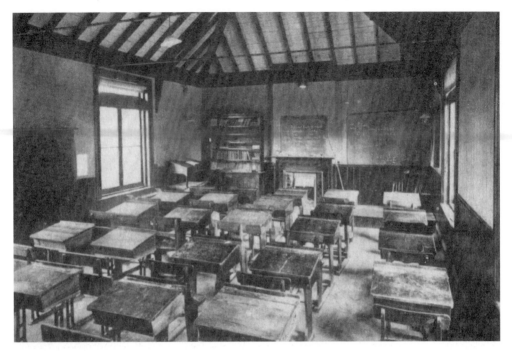

Interiors at Baswich House, which was a preparatory school during the 1920s. During the Second World War it was used as a home for an evacuated school from Ramsgate.

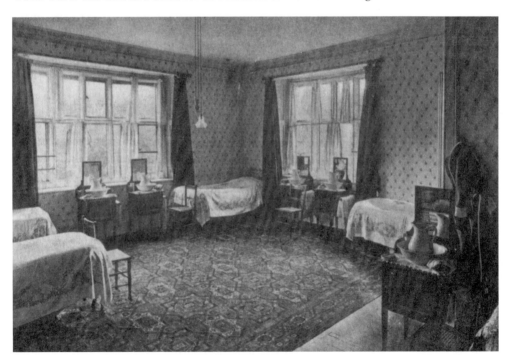

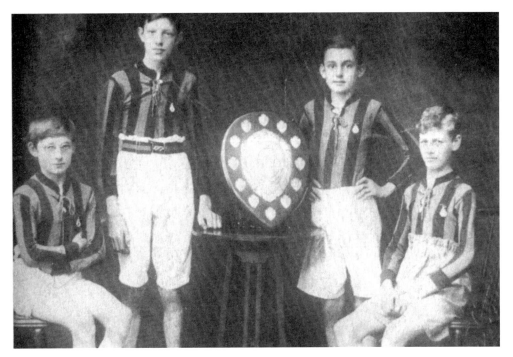

St Paul's School athletics team during the 1920s. Despite the handicap of their shorts, they were obviously successful.

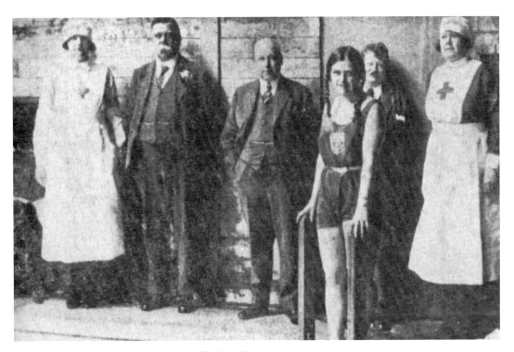

A teenage champion swimmer at Stafford Baths.

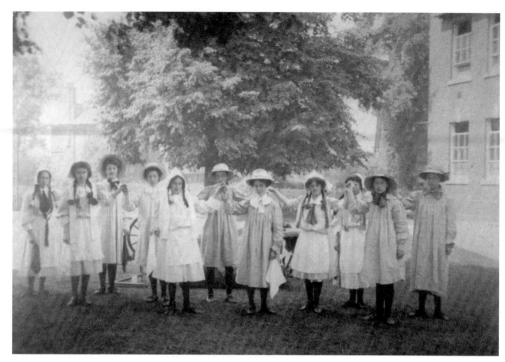

Stafford Girls' High School country dancing group, possibly about 1912.

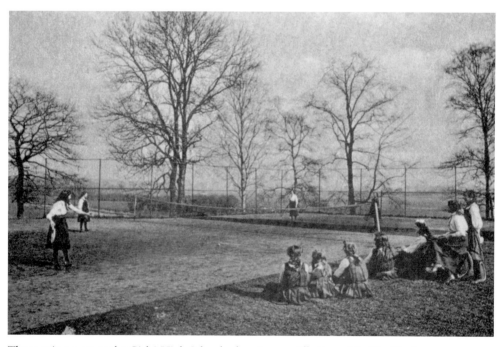

The tennis courts at the Girls' High School when it was still situated in The Oval.

## SECTION SIX

# An Honest Day's Work

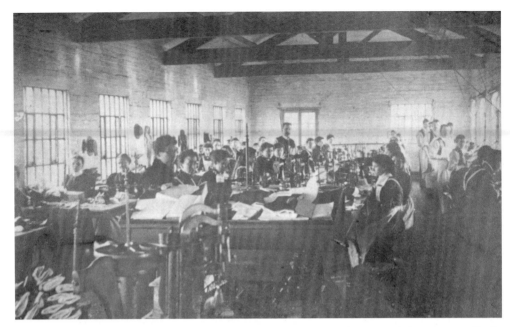

An interior view of Ward's shoe factory, *c.* 1910. The manufacture of boots and shoes was Stafford's main industry in the nineteenth century and was concentrated in the north of the town.

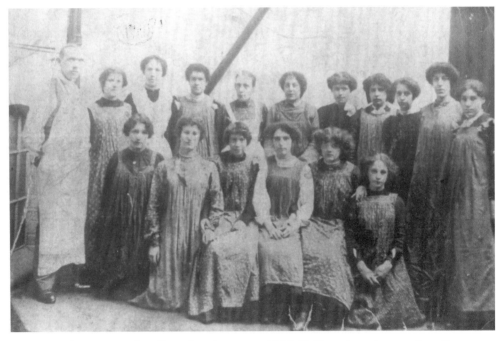

Women workers at David Hollins' shoe factory, *c.* 1905. Hollins, the only son of a railwayman, built one of the largest shoe manufactories in Stafford.

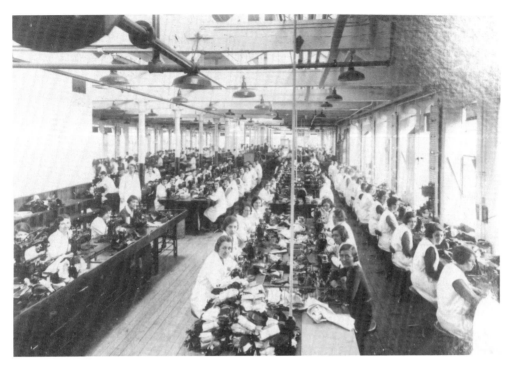

The finishing room at the Lotus factory in the 1920s.

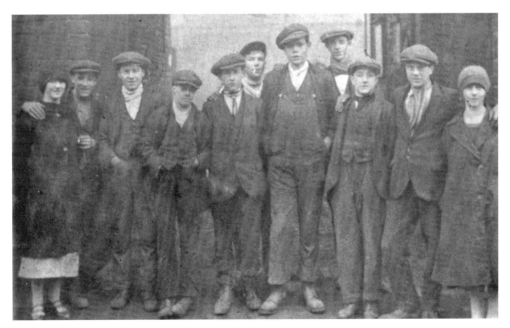

During the General Strike of 1926 apprentices were not allowed to strike, but these lads from a shoe factory came out for a few hours as a gesture of support to the men.

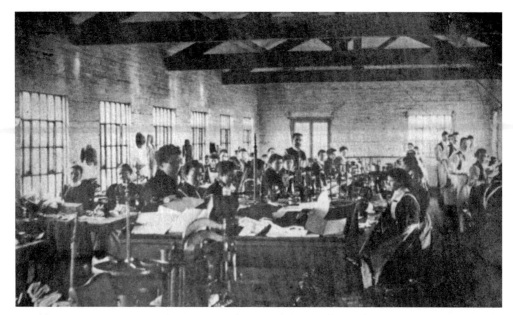

This eviction took place in 1926. The strike hit hard and many families found that they could not pay the rent.

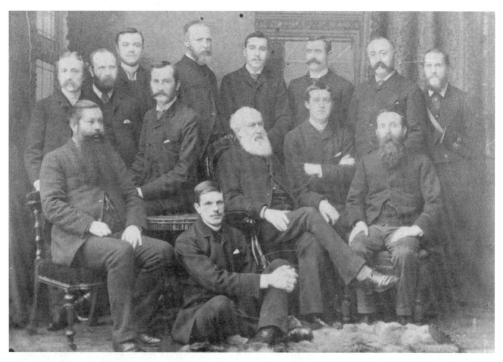

Lloyds Bank staff in the 1880s. The venerable looking gentleman with the white beard may have been the manager. The bank messenger is standing on the extreme right, still wearing his leather pouch.

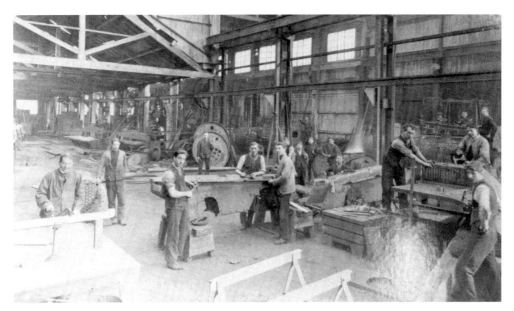

The Castle Engine Works in the 1920s. W.G. Bagnall opened his locomotive works in 1875 and the firm supplied railway engines all over the country and abroad. Originally one of the biggest employers in the town, the Castle Works has now closed as a locomotive builder.

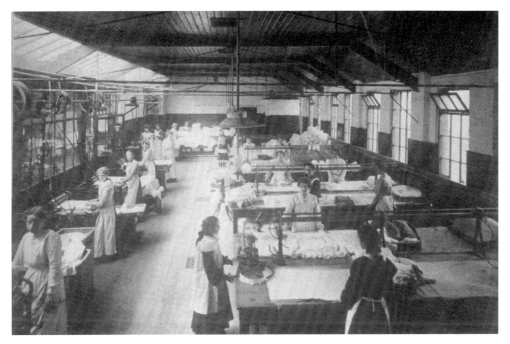

Stafford Steam Laundry ironing room, *c.* 1905. On the right gas irons are being used for pressing while the machines on the left were used to polish men's collars.

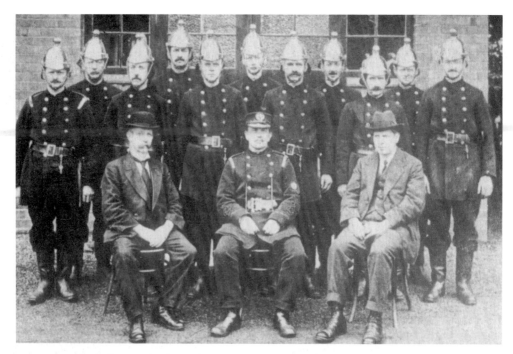

Siemens Brothers' factory fire brigade, *c.* 1910.

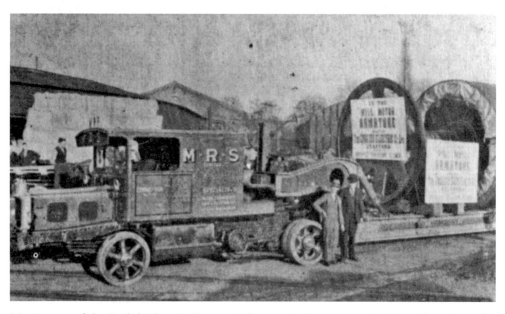

Moving one of the English Electric Company's largest single armatures in November 1935. The armature, weighing 73 tons, was manufactured in Stafford for the British Iron and Steel Company and conveyed by Marston Road Transport Ltd to Cardiff. Apparently the turn from Lichfield Road into Wolverhampton Road was completed in one sweep and the traffic was only held up for two or three minutes.

Baswich salt works. The discovery of a lake of brine under Stafford Common led to the opening of two salt works as well as to the building of the Royal Brine Baths in the town. It was hard and hot work. Welsh miners brought to work in the Stafford salt works during the First World War, disliked it so much that they went back to the mines within a week.

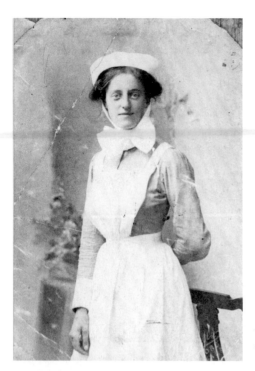

Mary Ann Astles, a nurse at the County Mental Asylum (St George's) in about 1910.

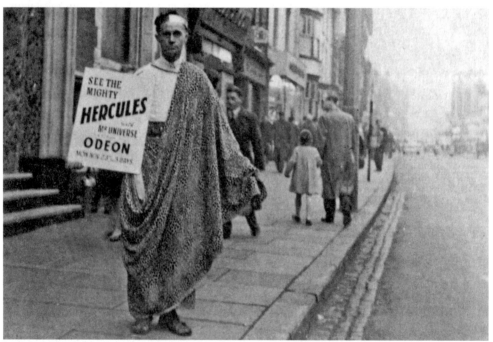

During the 1950s. the manager of Stafford's Odeon cinema was very enterprising when It came to advertising the Cinema programmes, as can be seen here in the costume of one of his commissionaires.

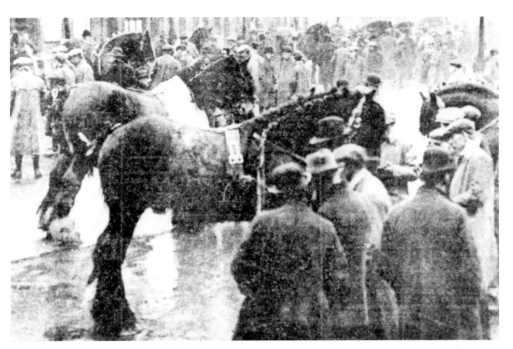

Livestock sales were held regularly in Stafford's streets: cows in Gaolgate Street, pigs in Eastgate Street and stallions in Pitcher Bank. This photograph was taken outside the William Salt Library in the 1930s.

The Talbot Smithfield in Tenterbanks in the 1930s. The church on the skyline is St Thomas', Castletown.

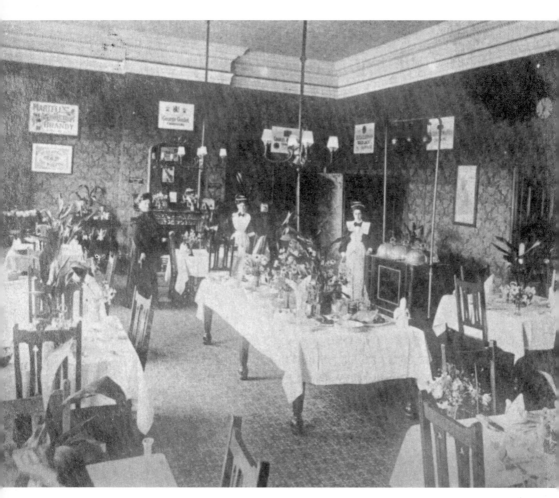

It is not possible to be certain which this is of several tearooms in Stafford before the First World War. It could well be Turner's Drapery Shop, which had a tearoom upstairs, and one waitress employed there before the First World War remembered the floor being covered with a kind of metallic linoleum which was very tiring on the feet.

# SECTION SEVEN

# The Sporting Life

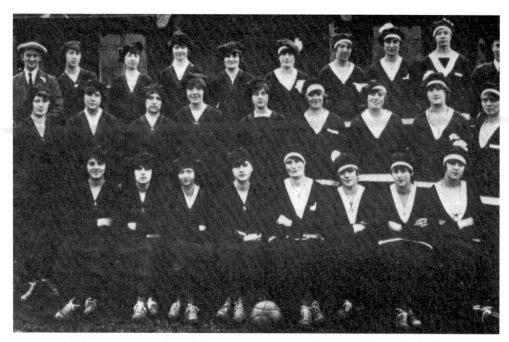

During the First World War, women took over many jobs while men were fighting at the Front. At Siemens Brothers' factory, women workers even formed their own football team.

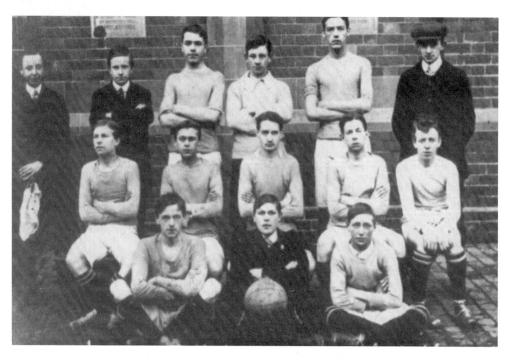

Sport was very popular among various church groups about this time. The Stafford Wesleyan Brotherhood managed to field at least two football teams.

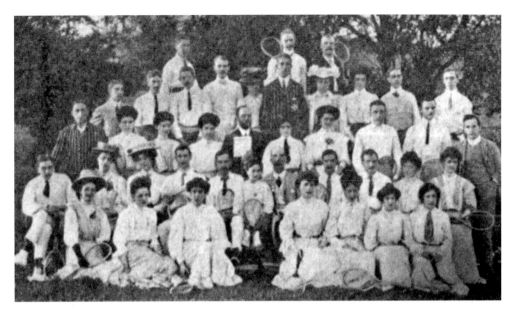

Stafford Institute Lawn Tennis Club, *c.* 1905. The elaborate hairstyles and cumbersome dresses obviously did not deter the ladies, but tennis must have been a hot game in those days.

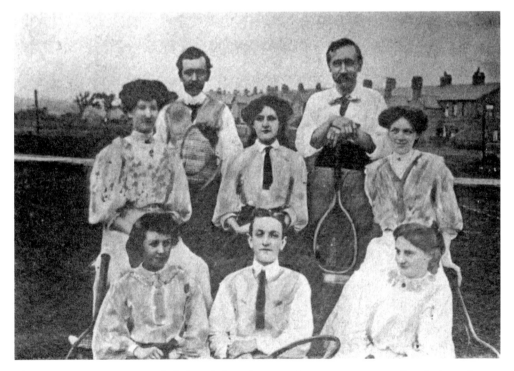

The Lotus tennis team, *c.* 1910. Local factories were keen to encourage the playing of sport among the workforce.

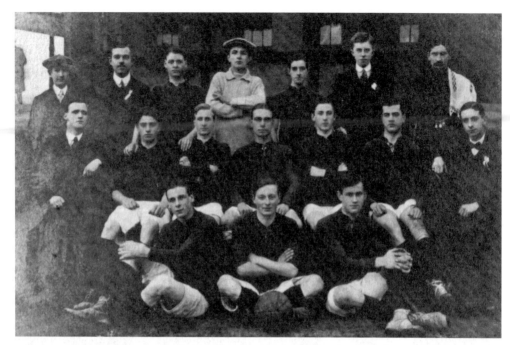

Siemens' factory junior football team, 1913.

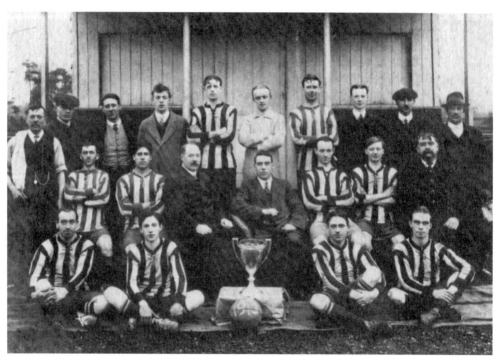

This photograph shows the winners of Siemens' departmental football competition in the season 1912/13. The large trophy was won by Shop 26 of the apparatus department.

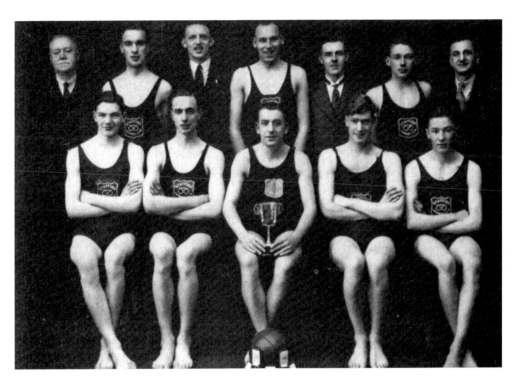

Stafford Swimming Club in 1935.

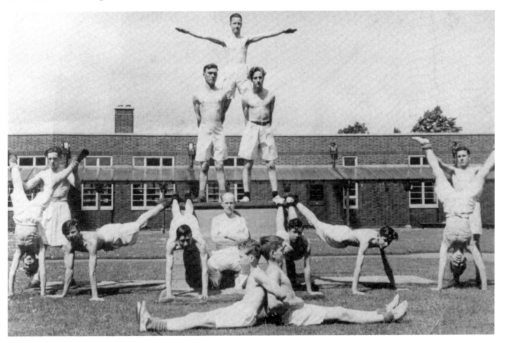

Gymnastic display held in the grounds of Riverway Secondary School, now Highways House, in about 1943. The proceeds were in aid of the Red Cross.

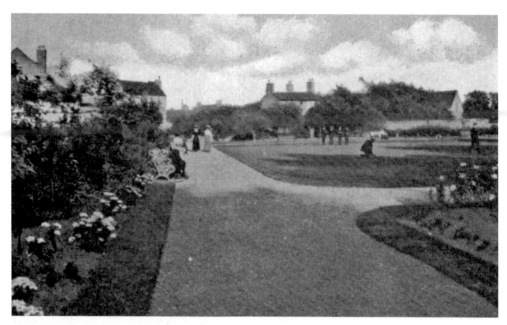

The bowling green in Victoria Park. This view must have been taken not long after the green opened in 1910. Since then it has provided many a happy hour's sport for Staffordians.

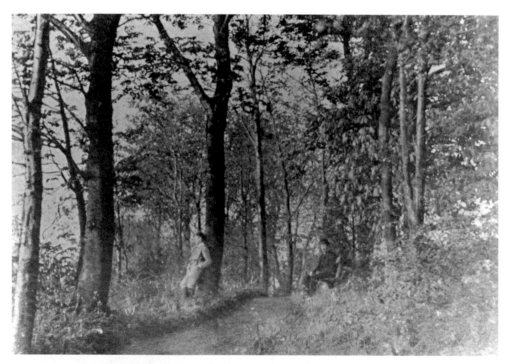

Brancote Woods on the edge of the town was a favourite spot for courting couples.

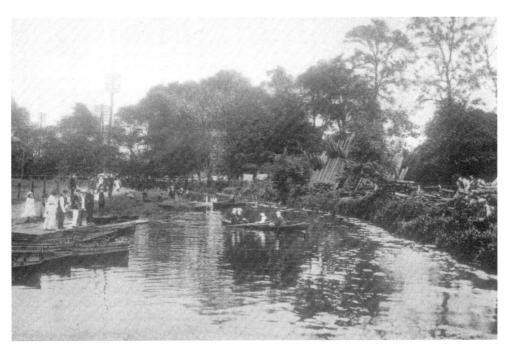

Boating on the River Sow was a popular pastime early in this century. The boats were kept at the Brine Baths and were run by Old Joe, the boatman, who would go out in another boat in pursuit of those who failed to return within the allotted time. It was possible to row out as far as Milford if you were prepared to carry the boat from the river to the canal at Baswich. On pageant days the boats were decorated with coloured lamps and people had to pay to see the water carnival. Canvas was stretched across the Green Bridge to ensure that no one could get a free view!

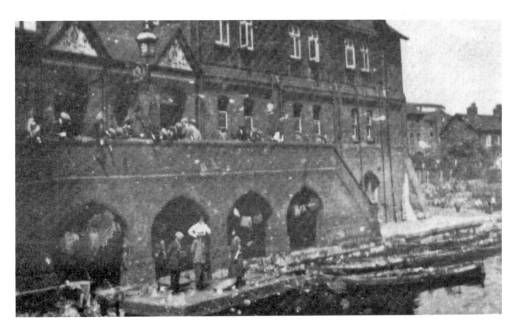

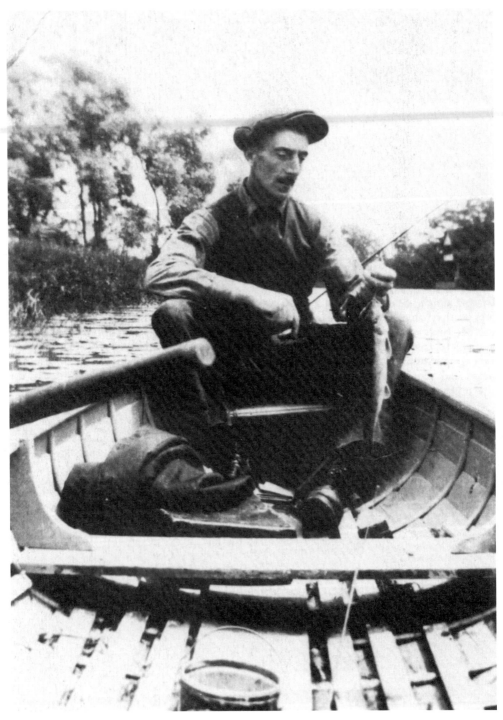

Fishing on the Sow during the 1920s, an appropriate sport for Staffordians since the town was the birthplace of Izaak Walton, the country's most famous angler.

# SECTION EIGHT

# The Home Front

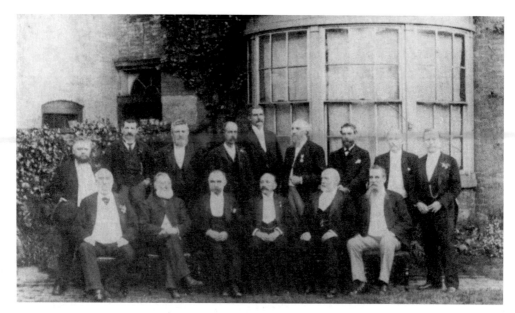

This group of 25th Staffs Rifle Volunteer veterans all served together in 1863 and are pictured here at a reunion in 1893. After a meal at The Vine Hotel, this select few were invited back to Dr Marson's house at 19 Eastgate Street where this photograph was taken. The house is now the William Salt Library.

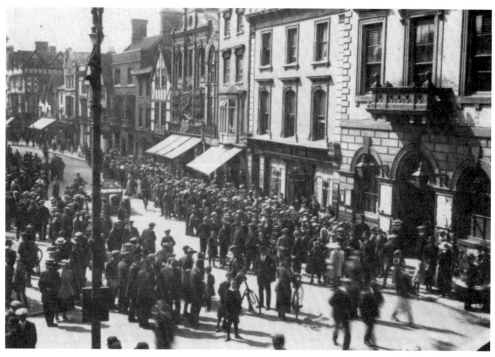

Volunteers queuing outside the police station in Market Square in order to enlist in 1914.

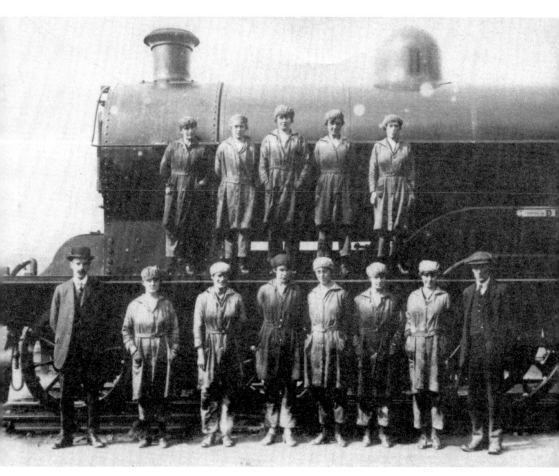

Women engine cleaners during the First World War. One woman in the photograph was sent to this job because she was temporarily unemployed. It was filthy, heavy work and she quickly found another job in a shoe factory.

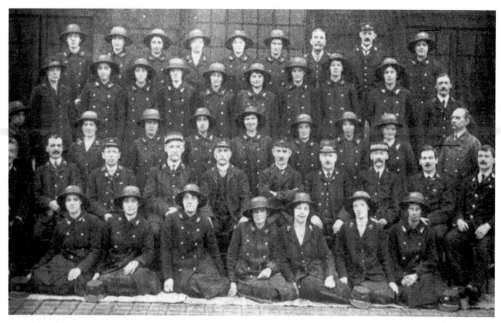

Postal workers, predominantly female, at Stafford Post Office in the First World War.

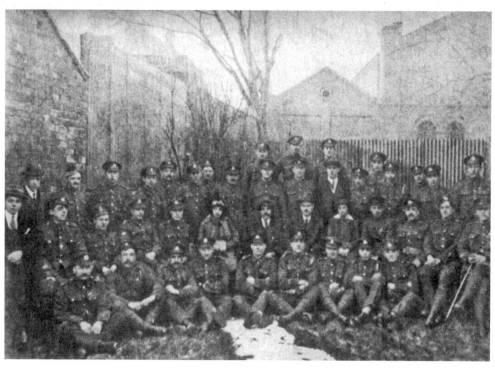

This photograph shows a group of former prisoners of war following their return after the end of the First World War. The buildings in the background are the Electricity Works in the Foregate.

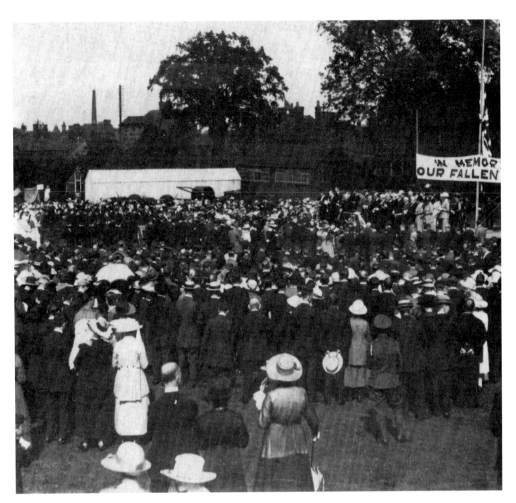

An open-air service held on the Grammar School field at the end of the First World War.

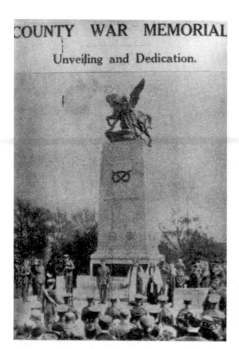

## COUNTY WAR MEMORIAL

Unveiling and Dedication.

The county town of Stafford has two war memorials. This shows the unveiling of the County War Memorial in Victoria Road in 1923.

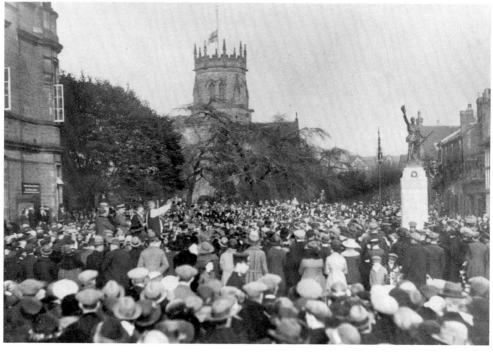

The unveiling of the Borough War Memorial in Victoria Square, 1922, in memory of the 584 Stafford men who lost their lives. The poignant figure of the lone soldier faces the railway station from which his comrades left the town to fight.

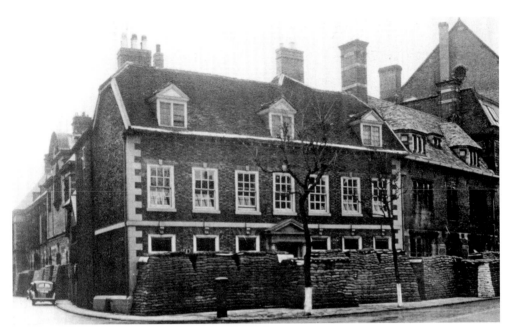

The present Registrar's Office in Eastgate Street was the Chief Constable's Office during the Second World War. It is seen here, like many public buildings, protected with a wall of sandbags.

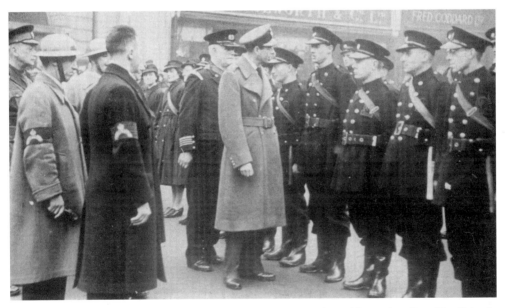

This photograph shows the Duke of Kent inspecting the Second World War Auxiliary Fire Brigade in Market Square. The duke was killed shortly afterwards in an air crash. The Auxiliary Fire Brigade was made up of volunteers and the Stafford men were called upon to help fight the fires in Coventry when it was almost destroyed by bombing.

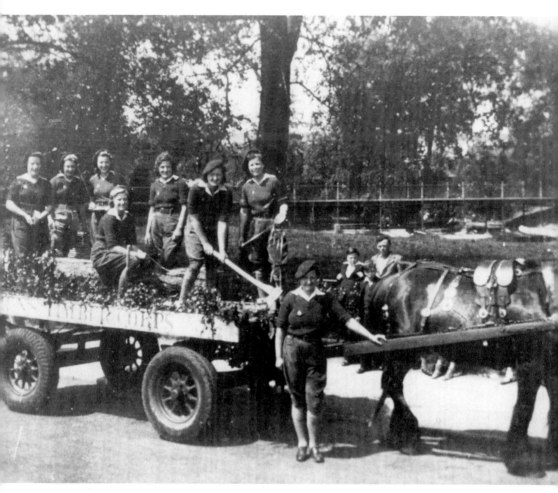

During the Second World War women took on the work of men who had gone to fight and many of them joined the Land Army and worked on farms. These next four photographs show the work of the Womens' Land Army Timber Corps. This cart with the girls in their smart uniform was probably arrayed for a victory parade after the war. It is seen standing in Newport Road, with Izaak Walton Walk in the background. This rural view is now obscured by a large garage.

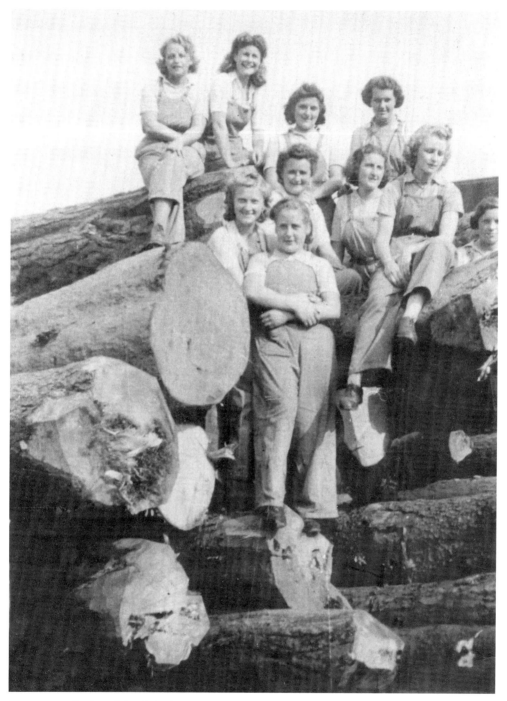

The tree trunks dwarf the slight figures of the Land Army girls as they pose with the timber which is awaiting their attention.

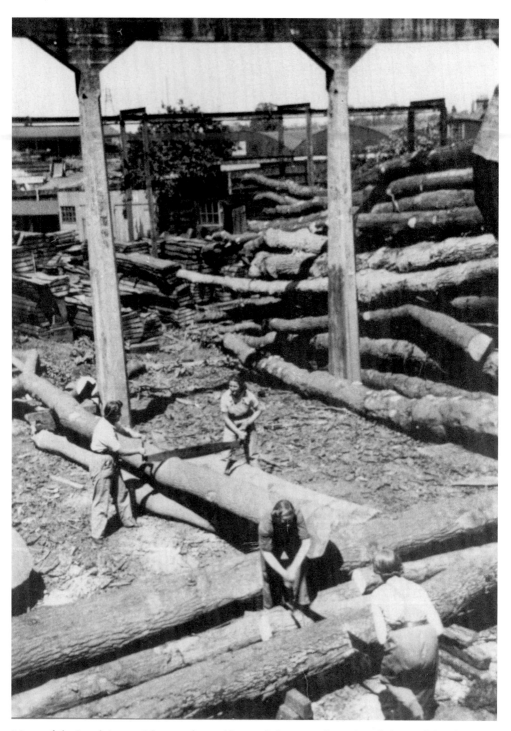

Many of the Land Army girls were from cities, and they must have found the work hard.

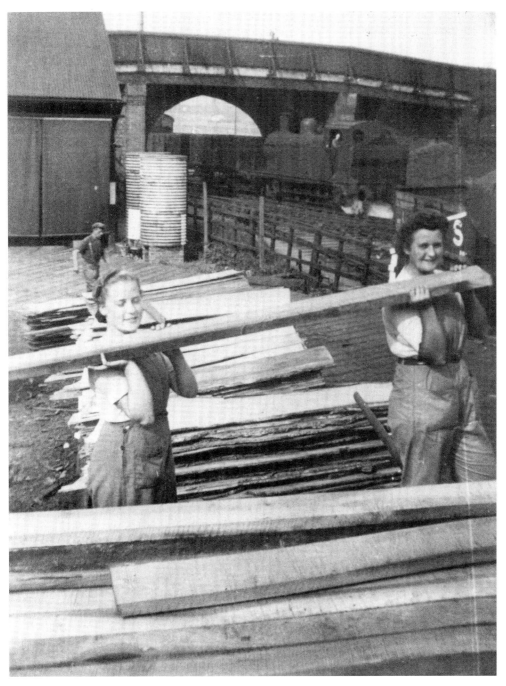

Here two of the girls are seen carrying sawn planks about Venables timber yard at Doxey. The railway bridge is Doxey Bridge, now demolished, and the lines have been removed.

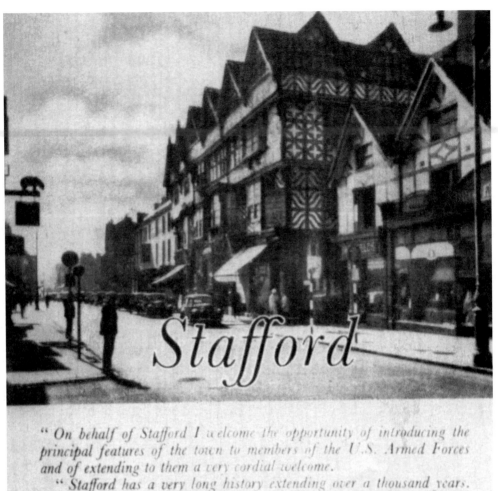

# Stafford

"On behalf of Stafford I welcome the opportunity of introducing the principal features of the town to members of the U.S. Armed Forces and of extending to them a very cordial welcome.

"Stafford has a very long history extending over a thousand years. For many centuries it was a typical County and Market Town. Although now mainly industrial it has not lost its ancient characteristics, and there are many old buildings which will prove of interest to visitors."

*A. E. Howard*

MAYOR 1943-1944

The cover page of a booklet produced by the Mayor of Stafford to welcome American troops stationed in Stafford in 1944.

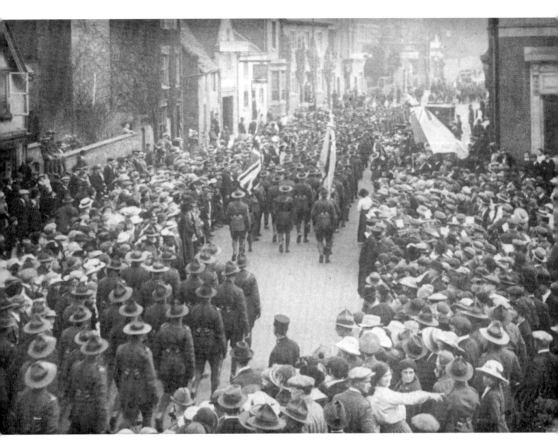

Troops from New Zealand marching through Stafford on their way back to Brocton Camp in 1919. They had just paraded in Market Square and had been presented with new colours by the Mayor of Stafford.

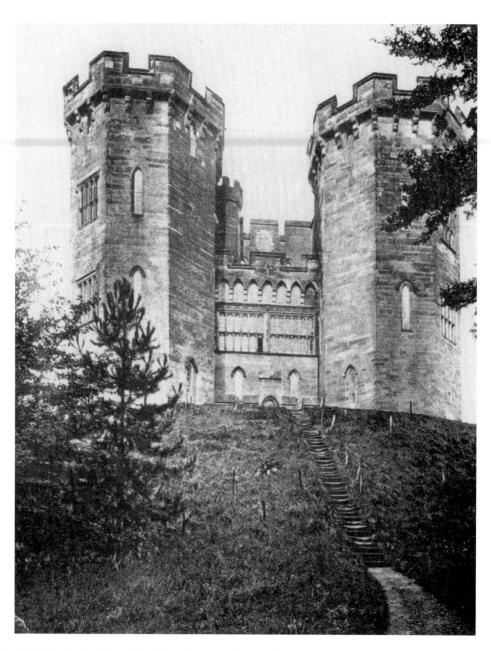

Stafford Castle in 1900. Rebuilt on the site of an earlier castle by Ralph, first Earl of Stafford, in the mid-fourteenth century, it was partially demolished by the Parliamentarians during the Civil War. It was restored by the Jerningham family during the nineteenth century and its outline became a well-known landmark. By the late 1940s, the building had fallen into disrepair and had become unsafe. Recent work at the site by Stafford Borough Council has safeguarded the castle's future and it is now used as a dramatic backdrop for outdoor theatrical productions while also providing further attractions for visitors.

# SECTION NINE

# Laughter and Tears

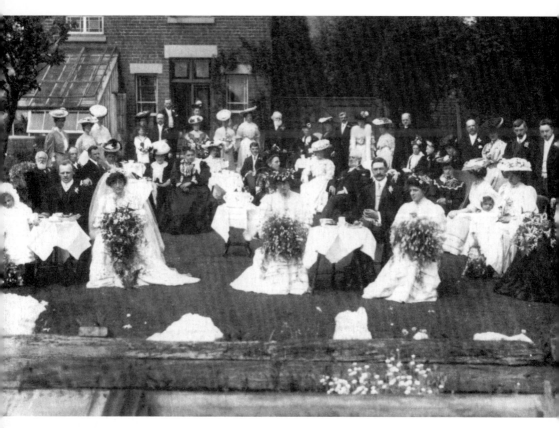

This wedding party in the garden of a Stafford house dates back to the end of the nineteenth century. We do not know the family or the home but it could be well be one of the large houses in Eccleshall Road. There is a profusion of flowers, not only in the bouquets of the bride and bridesmaids, but there are also two small flower girls and at least one lady guest is carrying a bouquet too. The hats are fashionably large and decorative and the wedding cake has a table to itself in the centre of the photograph.

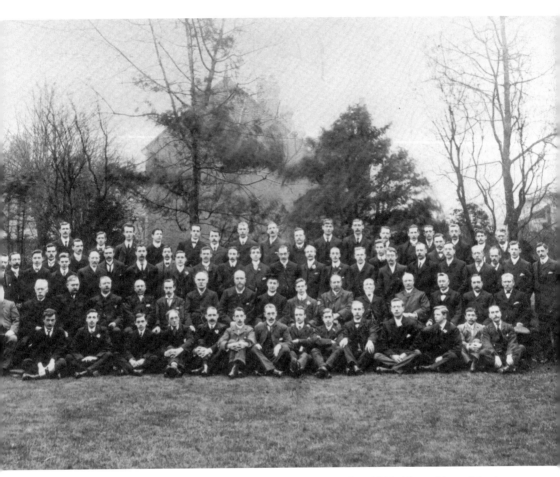

Christchurch Men's Group in the vicarage garden, Marston Road *c.* 1905. The gable end in the background is that of the end cottage in Albert Terrace.

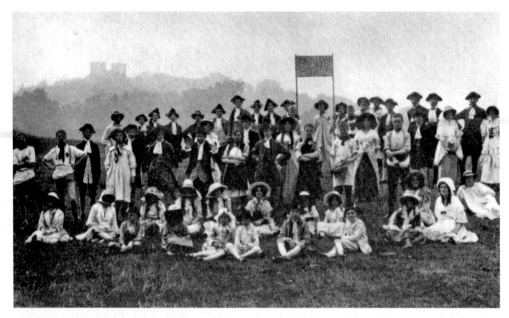

Stafford Millenary Pageant, 1913, showing one of the many historical scenes enacted. The silhouette of the castle can be seen in the background.

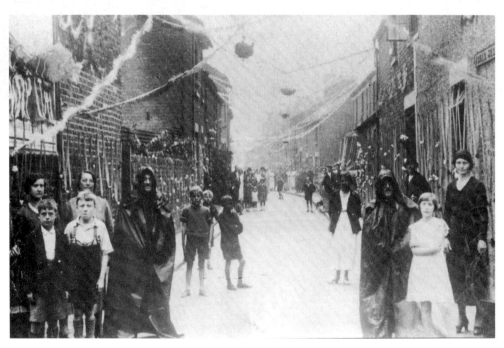

Friar Street decked out for the annual Hospital Pageant competition for the best decorated street, *c.* 1925, with a couple of unlikely looking friars.

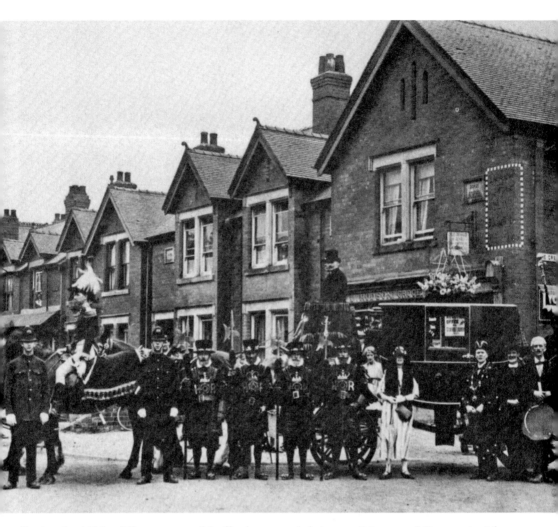

During the 1920s, different areas of Stafford presented their own 'Mayor and Corporation' for the annual pageant. This splendid effort was made by Doxey.

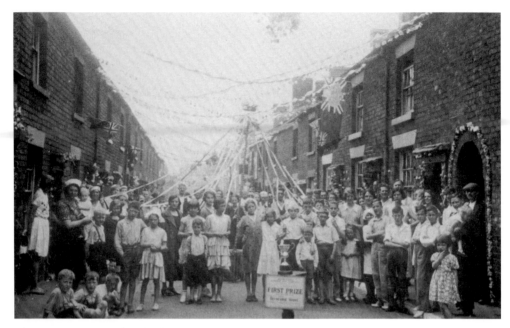

This street in the north end of the town won first prize in the pageant street competition, *c*. 1935. The theme was obviously May Day.

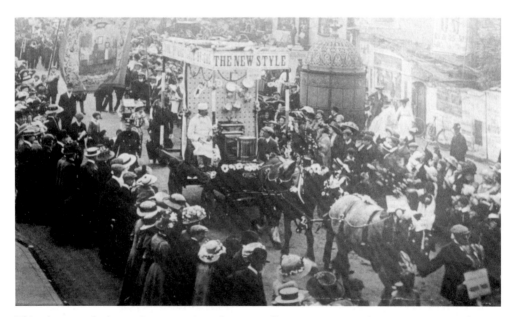

This photograph shows the procession of pageant floats entering Gaol Square, *c*. 1912. The one in the foreground is the winner, advertising the new gas cookers with the slogan 'Cook by Gas'. The floats wound their way to the Common where a funfair added to the celebrations. Note the ornate public lavatory to the right of the float.

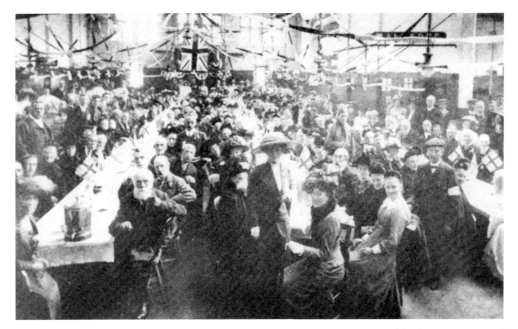

This pensioners' tea party was held to celebrate a patriotic occasion, possibly the coronation of George V in 1910.

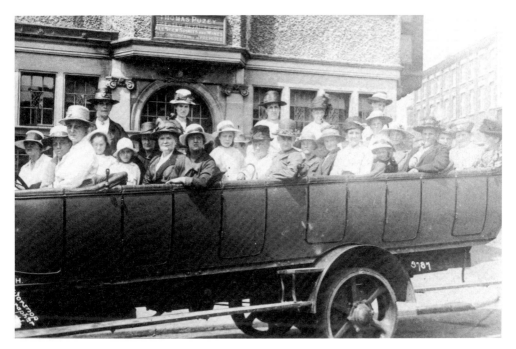

A charabanc outing waiting to depart from outside The Waggon and Horses, c. 1920. In the background Samuel and Johnson's shoe factory at 189 Foregate Street can be seen.

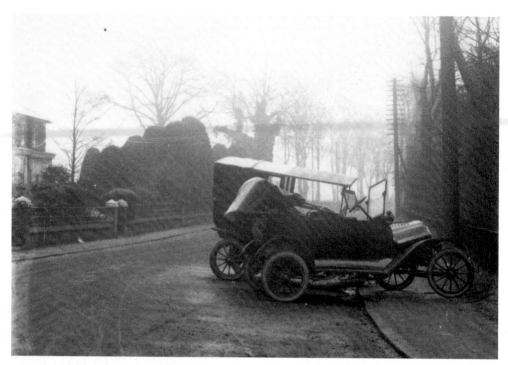

An early car crash at Queensville, *c.* 1920.

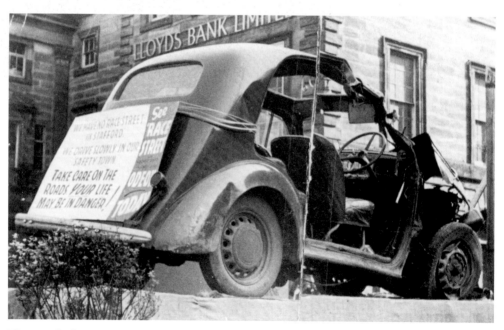

This wrecked car was set up in the Market Square to warn against the dangers of speeding and to advertise a film called *Race Street* at the Odeon.

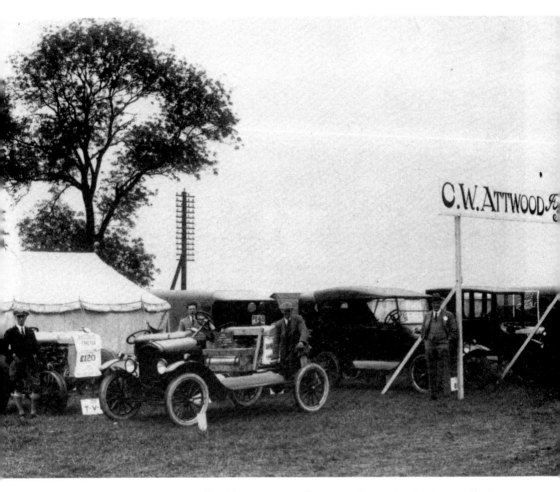

Attwood Garage's stand at the Staffordshire County Show, which is now held annually just outside Stafford at the county showground. This photograph was taken sometime during the twenties.

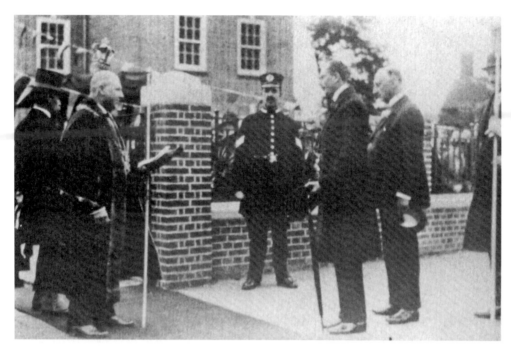

Prince Henry, who later became the Duke of Gloucester, opened the new David Hollins Nurses' Home next to the Infirmary in 1927.

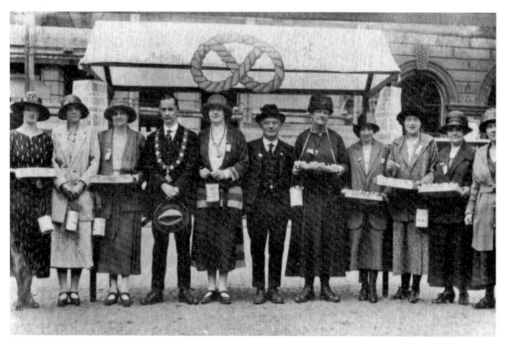

This group of charity flag sellers, pictured with the mayor in the early 1920s, raised a record sum of £50 for the Stafford Police Court Mission.

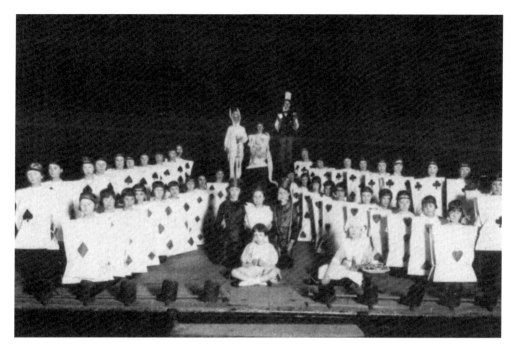

*Alice in Wonderland*, produced by Corporation Street School during the 1920s.

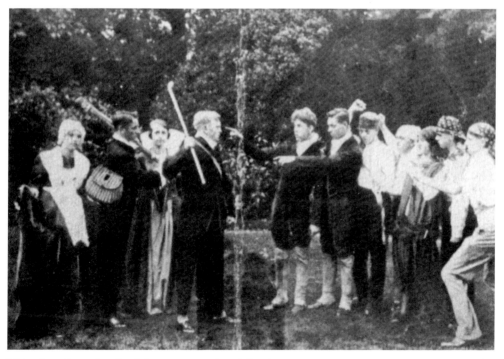

This play about Izaak Walton was produced by St Mary's Amateur Dramatic Society in the 1930s.

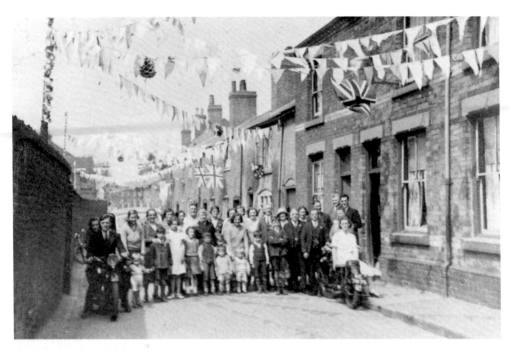

Inhabitants of South Walls pose formally in their street, decorated for the coronation of George VI in May 1937.

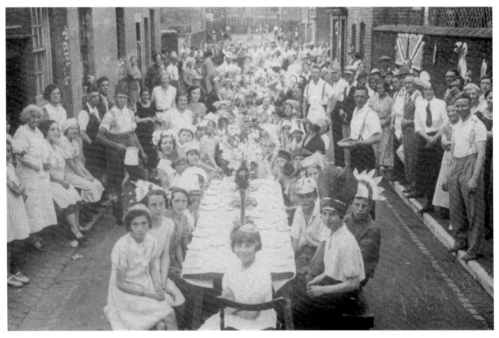

An informal photograph of a Stafford street party for the same coronation in 1937.

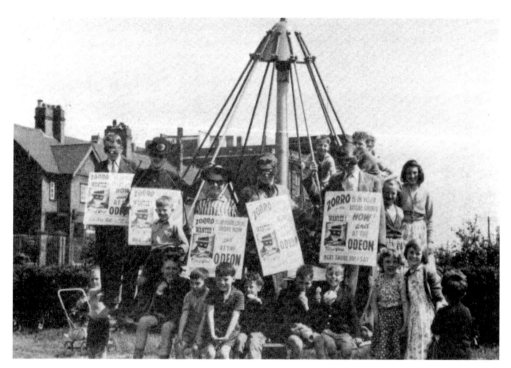

The cinema was a popular form of entertainment with both adults and children in the 1950s and '60s. These children on the playing field at Tenterbanks are helping to advertise the film *Zorro* at the Odeon.

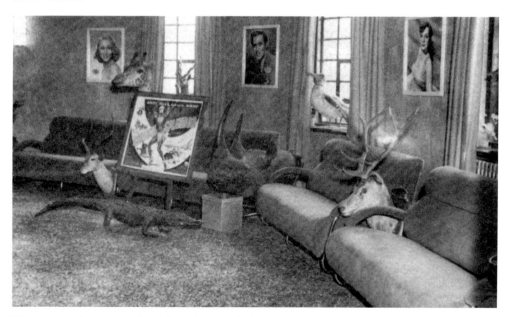

The art deco interior of the Odeon. The stuffed animals were not a permanent feature but were being used as a theme for the film of the week.

These two lifeguards posing outside the Odeon are advertising the MGM film *The Day They Robbed The Bank Of England* in the early 1960s. They also stood on the stage on each side of the screen but the horses bolted when the projection light came on. The first few rows of seats were almost destroyed but fortunately no one was sitting in them!

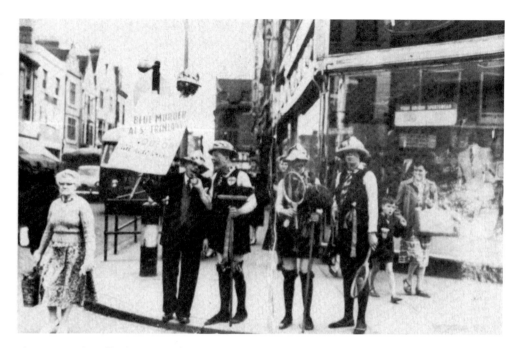

The corner of Stafford Street and Gaolgate Street with 'St Trinians' girls' demanding an audience for their film.

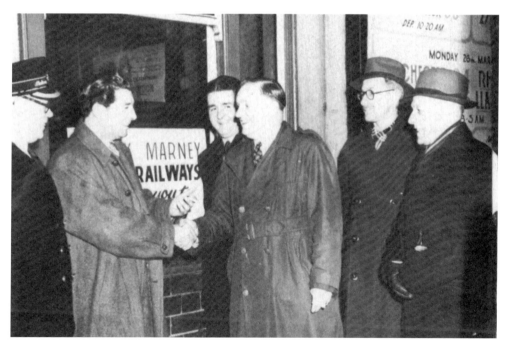

The Press Ball had a celebrity guest each year. Here, the actor Derek de Marney is seen being welcomed at Stafford station when he arrived to attend this event during the late 1950s.

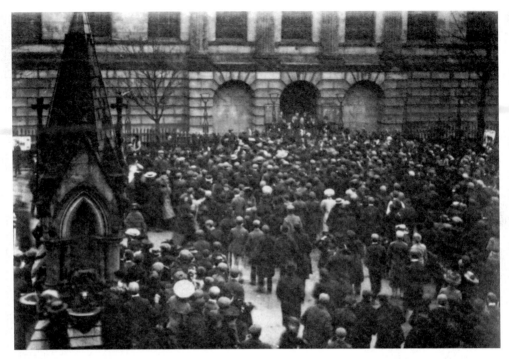

The election results of 1906 being announced outside the Shire Hall.

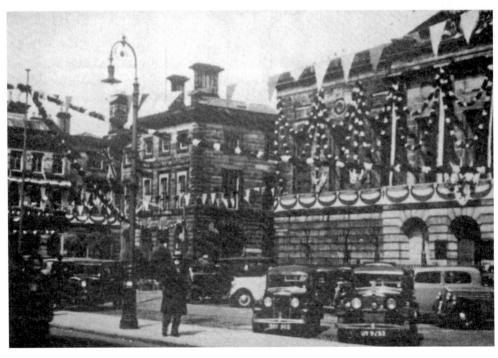

The Market Square *en fête*, either for the Silver Jubilee of 1935 or for the coronation of 1937.

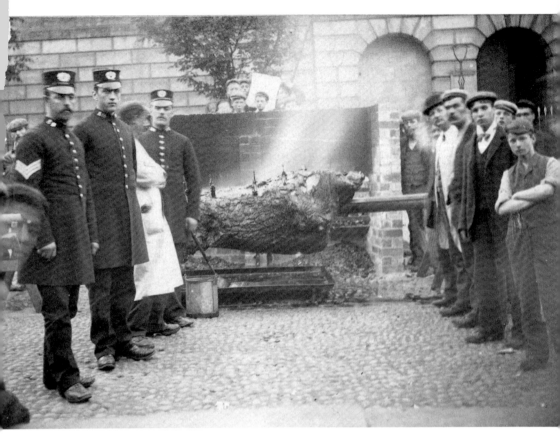

Market Square has often been the centre of celebrations of both national and local events and sometimes of mourning too. The ox roast pictured here is in celebration of Queen Victoria's Diamond Jubilee in 1897, although the serious expressions on the faces belie the joyful nature of the occasion. The old cobblestones in the square can be clearly seen.

# Acknowledgements

The compilation of a collection like this does not simply require effort and work by the compilers themselves. It also needs and depends upon the help and support of interested local people. Many such people have helped us to bring together the photographs in this book, either by generously lending their own photographs or by providing very welcome information and stories about the subjects of the photographs. Our grateful thanks are due to the following individuals and organizations:

Mrs J. Ashton • Mr P. Atkins, Editor of the *Stafford Newsletter* • Mrs Bayley • Mrs A. Clay
Ms J. Daly • Mrs M. Daly • Mr H. Dyson • Mr C. Ecclestone • Mr R. Faulkner • Mr J. Foster
• Mr G. Frape • Mr D.V. Fowkes, County Archivist • Revd T. Hawkings • Mrs J. Hedges
Mrs M. Hindle • Mrs E. Joynes • Mr R. Knight · Mr A. Leese · Mr C.D. Luft
Mr D.E. Morgan • Mrs W. A. Morgan • the late Mrs M. Mottershead • Mr P. Newbold
Mr V. Read • Mr A. Rogers • Stafford Historical and Civic Society
Staffordshire County Council, Depts of Education and of Libraries, Arts and Archives
Staffordshire Schools' History Service • Mrs Swanwick • Mrs M. Turner • Mr J. Weaver
the William Salt Library • Mr and Mrs Woollams • Mr J. Woolrich • Miss M. Yorke

In some instances the photographs lent to us were copies, and although every effort has been made to trace their origins it has not always been possible to do so. If we have failed to acknowledge anyone in the production of this book, then please accept our apologies. The responsibility for any errors and omissions rests entirely with us.

The royalties from this publication are being donated to the William Salt Library, Stafford.